LIFE WITHOUT INSTRUCTION

LIFE WITHOUT INSTRUCTION

SALLY CLARK

TALONBOOKS VANCOUVER 1994

Published with the assistance of the Canada Council

Talonbooks
201 - 1019 East Cordova St.
Vancouver, British Columbia
Canada V6A 1M8

Typeset in Palatino by Pièce de Résistance Ltée., and printed and bound in Canada by Hignell Printing Ltd.

First Printing: April 1994

ACKNOWLEDGMENTS: This play was commissioned by Nightwood Theatre in 1988, and was developed during an Ontario Arts Council Playwright's Residency in 1989. It was workshopped in 1990, under the direction of Kate Lushington and dramaturged by Jackie Maxwell. I would like to thank them both for their expert advice and encouragement.

Thanks also to Duncan McIntosh, Jon Kaplan, Urjo Kareda, and the Ontario Arts Council.

Canadian Cataloguing in Publication Data

Clark, Sally, 1953-
 Life without instruction

 A play.
 ISBN 0-88922-347-5

 1. Gentileschi, Artemesia, ca. 1597-ca. 1651—Drama. I. Title.
PS8555.L37197L53 1994 C812'.54 C94-910115-X
PR9199.3.C5235L53 1994

To Artists. And their models.

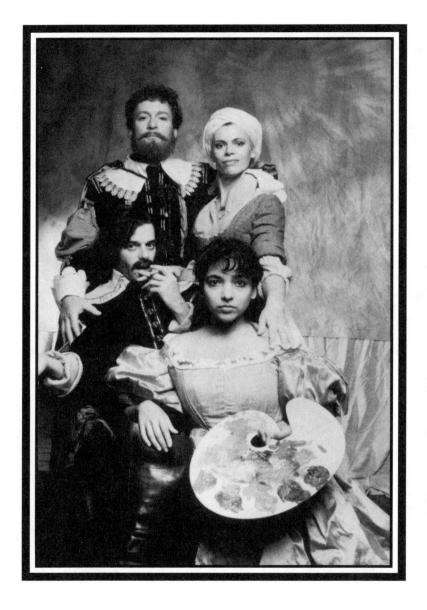

Clockwise from upper left: Benedict Campbell as ORAZIO, *Brenda Robins as* TUTIA, *Pamela Sinha as* ARTEMISIA *and Tom McCamus as* TASSI. *Photo by David Lee.*

Production Credits

Life Without Instruction premiered at Theatre Plus Toronto on August 2, 1991, with the following cast:

ARTEMISIA GENTILESCHI	Pamela Sinha
ORAZIO GENTILESCHI	Benedict Campbell
AGOSTINO TASSI	Tom McCamus
TUTIA	Brenda Robins
COSIMO QUORLI	Conrad Coates
GIAMBATTISTA STIATESSI	Damon D'Oliveira
LISA	Chick Reid
OLD MAN	Al Kozlik
INTERROGATOR	Richard Binsley
ASSISTANT INTERROGATOR	Ephraim Hylton
TONY	Antony Audain

Directed by Glynis Leyshon
Set and Costumes Designed by Phillip Clarkson
Lighting Designed by Lesley Wilkinson
Sound Coordinated by Chris Root and David Ross
Fights Directed by John Nelles
Theatre Plus Toronto Stage Designed by Michael Levine
Stage Manager: Sheila Z. Buchanan

CHARACTERS, SETTING & STAGING

ARTEMISIA GENTILESCHI, *Italian painter of the Caravaggio school, daughter of* ORAZIO, *age 15*

ORAZIO GENTILESCHI, *father of* ARTEMISIA, *painter, follower of Caravaggio, age 40*

AGOSTINO TASSI, *close friend of* ORAZIO, *age 30*

TUTIA, *chaperone to* ARTEMISIA, *age 25*

COSIMO QUORLI

GIAMBATTISTA STIATESSI

LISA

OLD MAN

INTERROGATOR

This play can be performed by 8 actors: 3 women and 5 men

The Biblical scenes are played as follows: ARTEMISIA as JUDITH, TASSI as HOLOFERNES, ORAZIO as RATZO.

There are no changes in costume between the Italian scenes and the Biblical scenes. The costumes for the play should be in the style of Caravaggio paintings, Italian early 17th century.

The first act of the play takes place in Rome in 1610. The second act takes place six months later.

ACT ONE

SCENE 1

A man and woman are lounging on a large mattress with many cushions. They are underneath a purple net canopy. The canopy is studded with jewels. The man, HOLOFERNES, is amorously drunk.

HOLOFERNES

Do you love me, Judith?

JUDITH

Of course I love you, my lord.

HOLOFERNES

You say that as though you're obeying orders. You're not my servant, Judith. You're a free woman. Your god and my god. We will rule together. Now, do you really love me?

JUDITH

Yes, I do.

HOLOFERNES

I sent everyone out so we could be alone. Not a very wise manoeuvre, is it?

JUDITH

Pardon?

HOLOFERNES

I am at your mercy.

JUDITH

Oh, my lord.

HOLOFERNES

You could do anything to me.

JUDITH

Oh, my lord.

HOLOFERNES

Why don't you start by kissing me?

JUDITH hesitates.

HOLOFERNES

Don't you want to?

JUDITH

Yes, of course. It's just that I've been in mourning for three years.

HOLOFERNES

Why did you change into these? *(fingers JUDITH's clothes)* Are you setting a trap for me?

JUDITH

No—of course not.

HOLOFERNES

That's a very beautiful dress you're wearing, Judith. *(runs fingers along JUDITH's bodice)* It seem odd to wear such enticing clothes and still be so shy. *(gazes at her)* God, you're beautiful. *(is about to embrace her—stops himself)* I refuse to make the first move. I'm tired of women claiming I rape them. You say you love me. Then, do something about it. Kiss me.

JUDITH kisses him.

HOLOFERNES

You can do better than that. There's a passion in you,
Judith. I can see it. Why are you hiding from me? *(kisses
her)*

JUDITH responds.

HOLOFERNES

(breaks away) Now, you kiss me.

JUDITH kisses him passionately.

Lights down.

*Lights up on JUDITH and HOLOFERNES, lying on
the mattress. Both are naked. The man is in a
deep sleep. JUDITH gets up and quickly puts on
clothes. She goes to the opening in the tent.*

JUDITH

(whispers) Tutia.

Silence.

JUDITH

Tutia!

*JUDITH's maidservant, TUTIA, enters. She is
holding a basket. She stands expectantly. JUDITH
goes off to one side.*

JUDITH

Oh Lord God of Israel, strengthen me. I must despise him.
On behalf of my people, fill my heart with rage that I may
do what I have promised.

She reaches for a large sword by the bed and holds it over her head.

HOLOFERNES moans.

JUDITH
Oh God! *(starts trembling, brings the sword back down to her side, looks over at TUTIA)* Tutia! *(sternly)* Hold his body down.

TUTIA positions herself to hold body down.

JUDITH raises sword over HOLOFERNES' head.

HOLOFERNES
Judith?

JUDITH brings sword down like a cleaver onto HOLOFERNES' neck.

Blackout.

SCENE 2

The young girl who played JUDITH *casually tosses the head of* HOLOFERNES *up in the air. She is a bit bored.* ORAZIO, *a man aged 40, is off to one side behind an easel. He is painting her. The young girl adopts a pose where she cradles the head in her lap.*

ORAZIO

That's right. Look down. *(opens a curtain)*

Light falls on one side of the girl's face—a Caravaggio effect.

ORAZIO

Perfect! Now hold it. *(starts painting)* Ah Bella, you'll never leave me, will you?

ARTEMISIA

Can I scratch my nose?

ORAZIO

Not yet.

ARTEMISIA

It itches. Why should I leave?

ORAZIO

Girls your age get restless. They don't want to be around old men like me.

ARTEMISIA

That's what Tutia says.

ORAZIO

What?! She's got her nerve.

ARTEMISIA

She says I should get married. She says it would be wrong
if I lived with you all my life.

ORAZIO

I don't care what people think. Do you?

ARTEMISIA

I never meet them. You never let me out.

ORAZIO

(throws down brush) Now, that simply is not true! You're
going to be a great painter. You don't have time to
gallivant around Rome, meeting people!

ARTEMISIA

The least you could do is give me a commission.

ORAZIO

You're not ready, yet.

ARTEMISIA

When?

ORAZIO

Soon. *(pause)* You know, you could "sort of" get married.

ARTEMISIA

Sort of?

ORAZIO

You could marry someone old who didn't have long to
live. He'd die and leave you comfortably well-off. So, it
wouldn't be as if you were actually married to him.

ARTEMISIA

Sounds creepy. Why can't I marry someone young? A
painter like me?

ORAZIO

You'd wind up having his babies and mixing his paints.
Painters are ruthlessly selfish.

ARTEMISIA

Oh.

ORAZIO

Yes! I've got it. Yes, it's there! *(stands back from easel)*
That's what it is. A frozen moment in time. All moments
combining to form one moment—the essence of
everything that came before and will follow after. And I
have captured it. At this moment, in my painting, Bella,
you are perfection itself. Nothing can change that. *(sighs)*
I am an artist, Bella, because I hate change.

ARTEMISIA

Let's see. *(goes over to painting, and is disappointed)* It looks
just like me.

ORAZIO

Yes. I've finally captured you.

ARTEMISIA

But it should look like Judith. I was trying to be Judith.

ORAZIO

I wondered why you had that strange expression on your
face. I just ignored it.

ARTEMISIA

You made me look like a little girl. Why did you even
bother telling me I was Judith.

ORAZIO

It's just a story. Clients like Biblical themes.

ARTEMISIA

What's the point of painting the story if you don't believe
it.

ORAZIO

I was painting you.

ARTEMISIA

You should paint the story.

ORAZIO

Trying to tell me how to paint now, are you. Remember,
Missy, everything you learned, you learned from me.

ARTEMISIA

I know. *(pause)* I think I need another teacher.

ORAZIO

What?!

ARTEMISIA

You want me to be the best. Then please, let me study with
Caravaggio.

ORAZIO

Not that again!

ARTEMISIA

But Caravaggio is—

ORAZIO

Don't say that name in my studio!

ARTEMISIA

Caravaggio!! Caravaggio!! *(dances around)*

ORAZIO

Stop it! Stop it this instant!!

ARTEMISIA

(sing-song) C-a-a-r-a-v-a-a-g-g-i-o!!

ORAZIO

ALL RIGHT! ALL RIGHT! I'll find you a teacher.

ARTEMISIA

Cara—?

ORAZIO

NO! *(pause)* Someone else.

ARTEMISIA

Who, Daddy? He's got to be good. I want the best—

ORAZIO

(studies painting) Don't nag. *(smiles)* If you ever leave, I'll have you here. I've captured your soul, Bella. You're in my canvas forever.

ARTEMISIA

I'll have to put you in my painting, then.

ORAZIO

Make me young, Bella. Paint me young.

ARTEMISIA

(laughs) Daddy!

Scene 3

Art Studio.

Orazio and his friend, Agostino Tassi stagger in. They are both drunk. Tassi looks like Holofernes.

ORAZIO

Come here. I want to show you something.

TASSI

No.

ORAZIO

Whaddya mean, no?

TASSI

I don't want to see it.

ORAZIO

What the hell is that supposed to mean!

TASSI

We go out. We get drunk. You drag me back to your studio and I'm supposed to tell you how great your work is. Well—I'm fucking sick of it. Your work is shit.

ORAZIO

You're just saying that because you're drunk. *(tries to haul him over to easel)*

TASSI

No. I'm not.

ORAZIO
Your work isn't so great either, you know.

TASSI
At least I'm not stupid enough to think I'm a painter. I
have one craft and I master it. Drawing. That's what's
really wrong with your paintings. You can't draw. Your
colour sense is god-awful but the main problem is you
can't draw.

> *While TASSI is talking, ORAZIO takes the canvas
> off the easel and thrusts it in front of TASSI.*

ORAZIO
(announces) "Judith Beheading Holofernes"!

TASSI
Christ! What'd you do to me?!

ORAZIO
Don't take it personally, Tassi.

TASSI
That's my goddamn head in her lap!

ORAZIO
I thought I better show you first. It's a commission.

TASSI
Severed heads. Everyone's painting severed heads these
days. Why the fascination? And why does it have to be my
head. It's unlucky, for Christ's sake!

ORAZIO
Actually, your head was the reason for the commission.

TASSI

Who would do that?!

ORAZIO

You can't think of anyone?

TASSI

I can think of a whole bunch of people but none of them
have any money.

ORAZIO

Your sister-in-law's husband.

TASSI

Oh. The Old Man. *(looks at painting)* Where did you find
that little lardo?

ORAZIO

I beg your pardon.

TASSI

The model. A real dog.

ORAZIO

She has a certain spiritual beauty.

TASSI

(scrutinizes painting) I wouldn't fuck her if my life
depended on it.

ORAZIO

AAAAGGGH! *(goes to hit TASSI)*

TASSI

(ducks) Ratzo— Ratzo— What's the matter! Look, I'm
sorry. Are you having an affair with this broad?

ORAZIO

SHE'S MY DAUGHTER! YOU NIT!!

TASSI

Oh. *(pause)* God, she looks just like you. Sorry. I didn't
know you had a daughter. I've met your sons. Why
haven't I met her?

ORAZIO

She keeps close to the house.

TASSI

What do you do? Lock her up. Did the Old Man put in a
special request for your daughter, too?

ORAZIO

Well—it was—hem—a deal we had—it fell through.

TASSI

You mean you—

ORAZIO

Good God! Nothing so sordid. Marriage.

TASSI

To that old lech. That's worse.

ORAZIO

I don't want her to marry the first young boob she lays
eyes on.

TASSI

What else is she supposed to do.

ORAZIO

You don't understand. Bella is not like other girls. She's—
well—she's precocious.

He starts rummaging for another canvas.

 TASSI

You don't say.

 ORAZIO presents another canvas to TASSI.

 TASSI
Oh please, Ratzo. I'm just not in the mood to look at—

 ORAZIO
(thrusts TASSI at canvas) "Susannah and the Elders"!

 TASSI
(stares at it) I didn't know you painted nudes.

 ORAZIO

You don't like it.

 TASSI
There's a living body here. It's not your usual shit, Ratzo.
This is a well-observed human form. My God, Ratzo, after
all these years of being a third-rate Caravaggio, can it be
possible that—

 ORAZIO
I was doing light and dark long before he was. He stole
my ideas!

 TASSI
Jesus, sorry to bring all that up again. But, this is good.
Except the perspective is all off. What are those two black
lumps over her head?

 ORAZIO

Elders.

TASSI

Trees? They don't look like trees.

ORAZIO

No. Elders! Old guys. That's me, you idiot!

TASSI

You don't flatter yourself.

ORAZIO

No. *(looks at it closely)* I don't. The other one's not done yet.

TASSI

She has a delightful body.

ORAZIO

Who?

TASSI

The model. Really firm. Good tits. I love it when they point up. All that hope and optimism in that firm little breast pointing up. Then, of course, they get old and grumpy and the breasts sag down to their navel and life is hell.

ORAZIO

Oh yes. How is your wife?

TASSI

Dead.

ORAZIO

What?

TASSI

Yeah. She died.

ORAZIO

Didn't she—

TASSI

Ratzo, you sly old bugger—you want to know the dirt.
She ran off with her lover and she died.

ORAZIO

Did he kill her?

TASSI

Not intentionally. Too much sex.

ORAZIO

Really?

TASSI

How should I know. She ran off and now she's dead. I
couldn't care less. Who's the model—

ORAZIO

You don't draw nudes.

TASSI

Who said I was going to draw her. Who is she?

ORAZIO

No one you know. *(flips a cover over the painting)* I wanted
your opinion of the work.

TASSI

I was just getting to it. *(removes cover)* This painting,
Ratzo, is the best painting that you have ever done. Your
colour sense here is superb. Usually your colours are all
muddy. And the body—well—it is magnificent!

ORAZIO

(sighs, and puts the cover back over the painting) Thanks.

TASSI

You don't seem very happy about it.

ORAZIO

I didn't paint it.

TASSI

What.

ORAZIO

My daughter painted it.

TASSI

Your daughter. *(pause)* You're being funny, aren't you?

ORAZIO

No.

TASSI

You taught your daughter how to paint?!

ORAZIO

I didn't mean to. When Prudentia died, Bella wouldn't leave my side. Followed me around the studio like a little dog. She helped me with my painting. Then, she started to do her own work.

TASSI

She's good.

ORAZIO

Good? She's brilliant! I taught her everything she knows. *(pause)* So why is she so much better than me? *(breaks*

down) I taught her my colours. But she uses her own. And they're better.

 TASSI
Maybe she's been seeing Caravaggio.

 ORAZIO
I don't let her out of my sight!

 TASSI
I was just kidding, Ratzo. Get a grip on yourself.

 ORAZIO
She will be better, though. She will be the best. She is my revenge on that sonofabitch.

 TASSI
It's not too late. You could still apprentice one of your sons.

 ORAZIO
What are you talking about?

 TASSI
She'll get married and have kids and forget all about painting. You're wasting your time.

 ORAZIO
But she has genius!

 TASSI
That may be true. But what does this painting say? It's a girl's painting. It's well-crafted but it's empty. You've locked her away from the world and now you expect her to have something to say about it.

ORAZIO

But—

TASSI

You don't want her to lose her innocence. Put her in a nunnery and have done with it. *(takes a swig of wine, starts to leave)*

ORAZIO

You're right. She does need to learn about the world.

TASSI

She needs to learn perspective.

ORAZIO

You could teach her, couldn't you?

TASSI

You don't want her to get married.

ORAZIO

No.

TASSI

My price is high.

ORAZIO

For a friend?!

TASSI

She's an ugly girl.

ORAZIO

You dare to insult my dead wife?!

TASSI

Your wife was gorgeous, Ratzo. This girl looks like you.
Plug ugly.

ORAZIO *punches* TASSI, *knocks him out.*

TASSI *falls in a heap on the floor.*

ORAZIO

Oh my God! Tassi! *(slaps him)* I didn't kill you, did I?
(rolls him over with his foot) Christ! I need a drink.

He grabs a bottle of wine, gets the "Judith"
painting, props it on the floor near him, and,
using TASSI *as a cushion, lies against him. He
gazes at the painting.*

ORAZIO

Bella.

He falls asleep.

Lights down.

ARTEMISIA *pokes her head in. She is wearing a
nightgown. She enters with a candle and stares
at* TASSI. *She puts the candle down, grabs some
paper and a pencil lying around in the studio
and proceeds to draw* TASSI'*s head.*

SCENE 4

The Studio.

ARTEMISIA is painting TUTIA.

TUTIA

(telling a story) "And Romeo looked around the crowd of young girls—their eyes glittering under their masks. And there in the centre was the most beautiful girl he had ever beheld."

ARTEMISIA

How could he tell she was beautiful if she had a mask on?

TUTIA

Oh, that's right. "Well, the girls all removed their masks and there in the centre of the circle was the most beautiful girl Romeo had ever beheld."

ARTEMISIA

What makes someone beautiful?

TUTIA

You're either born that way or you're not.

ARTEMISIA

My father says I'm beautiful.

TUTIA

Your father loves you very much.

ARTEMISIA

It's funny, you know, Tutia. 'Cause I don't feel beautiful.

TUTIA

No kidding.

ARTEMISIA

I feel big and clumsy.

TUTIA

Well, you're growing.

ARTEMISIA

I feel as if I'll never stop. Look how big my hands are.

TUTIA

And your feet.

ARTEMISIA

Do you think Juliet was big like me?

TUTIA

(hastily) No! I mean—she was probably smaller.

ARTEMISIA

Yes. I think so, too. She feels like a small person to me. My mother was big.

TUTIA

You were only a little girl. How would you know.

ARTEMISIA

I was nine. I remember exactly what she looked like.

TUTIA

You should ask your father to take you out more often. Wouldn't you like to go to a ball like Juliet's?

ARTEMISIA

A ball?

TUTIA

That's what most girls your age do. Your father should—

ORAZIO sits bolt upright from a pile of drapery.

TUTIA

(sees him—gasps) AH! *(clutches heart)*

ARTEMISIA

(takes no notice) Afternoon, Daddy.

ORAZIO

(with great pronouncement) You are going to have Instruction.

ARTEMISIA

You found me a teacher?! Who?!

ORAZIO

Instruction in the art of Perspective. Taught by the best draughtsman in all of Rome. Agostino Tassi. *(gets up carefully—starts to stagger out the door, moaning)*

ARTEMISIA

Oh, thank you, Daddy! But he's not a painter. Don't you think—

ORAZIO

(waves her off) Not another word. I have Decided. *(leaves)*

TUTIA

You might have told me he was here.

ARTEMISIA

Sorry. I forgot.

TUTIA

You'll have to get a new dress.

ARTEMISIA

Why?

TUTIA

For your classes.

ARTEMISIA

You don't wear good clothes when you paint.

TUTIA

You do when Agostino Tassi is your teacher. He's so handsome.

ARTEMISIA

Oh. Do you think so?

TUTIA

Oh yes, he's very clever, too. And he's a widower. You could marry him.

ARTEMISIA

Are you crazy?

TUTIA

Wouldn't you like to marry Signore Tassi?

ARTEMISIA

He's a friend of my father's. He's old.

TUTIA

He's only thirty and he has all his teeth.

ARTEMISIA

(lays down paint brush) Come on. Let's play "Judith." *(goes over and pulls TUTIA off the model stand)*

TUTIA

You're too old to play games. Your father would have a fit if he—

ARTEMISIA

I can't do anything anymore! I can't play games! I can't go out by myself because I'm too old and I'm supposed to be a lady. What's the point of being a lady if you can't do anything!!

TUTIA

Stop complaining. You have more freedom than most girls your age. Most girls wouldn't be frittering away their time painting. Most girls would be doing chores. Helping their mothers.

ARTEMISIA

(starts to cry) It's not my fault my mother's dead!

TUTIA

Oh Bella, I'm sorry. I didn't mean it that way. Please stop crying. We'll play the game.

ARTEMISIA *shakes her head "no."*

TUTIA

"In the town of Bethulia, there lived a young woman whose name was Judith. She was very beautiful but it was hard to tell because she wore black all the time. Those ugly black widow's weeds totally covered up her delicate features—her tiny feet and trim little—"

ARTEMISIA

"She was very large. She had huge massive shoulders and big huge hands. Judith was about six feet tall. But that was all right because her dead husband was even bigger. He was 6 foot 5. No one would marry Judith because she was too big for them. Even though she was beautiful."

TUTIA

She was not big! It doesn't say anywhere in the Bible that Judith was big.

ARTEMISIA

She'd have to be pretty big to saw off a man's head.

TUTIA

She cut it neatly in two strokes. The way you slaughter a pig.

ARTEMISIA

No. She must have sawed it off. Like she was cutting wood.

TUTIA

I don't know why you focus on the most disgusting part of the story.

ARTEMISIA

That's the best part.

TUTIA

That's not the best part. The seduction of Holofernes is the best part. "The Assyrian general, Holofernes, had jet black hair, a jet black beard and flashing blue eyes. He was a wicked evil man. Totally unscrupulous and very attractive to women. He was very tall. At least 6 foot 7."

ARTEMISIA

He was not!

TUTIA

I'm telling the story now. "His army held the town of
Bethulia under siege to try and force the Jews to pay
homage to Ozymandias. Holofernes' men were very evil.
If they saw a young woman on the street—"

*ARTEMISIA pretends to be walking down the
street.*

TUTIA

"They would loosen her head-dress to defile her." *(pulls
ARTEMISIA's hair)*

ARTEMISIA

OW!

TUTIA

"Strip her thigh to shame her." *(rips off ARTEMISIA's art
smock)*

ARTEMISIA

Hey! That's my smock.

TUTIA

You can fix it. You need a new one, anyway. "And profane
her womb to disgrace her." *(yanks ARTEMISIA to her and
throws her on the ground)*

ARTEMISIA screams.

*ORAZIO appears in the doorway, clutching his
head.*

ORAZIO

WHAT THE HELL IS GOING ON HERE!!

ARTEMISIA

Oh, hi, Daddy.

TUTIA

(straightens herself out) Signore Gentileschi.

ARTEMISIA

We were just playing, Daddy.

ORAZIO

WHAT SORT OF—

TUTIA

Actually, we were practising scenes for Bella's next painting.

ORAZIO

The rape of the Sabine women? I'll not have you—

ARTEMISIA

No. "Judith."

TUTIA

Bella admires your painting so much, Signore, that she wants to do one as well.

ORAZIO

Oh. A pretty strange way to go about it. Your classes start tomorrow, Bella. Go fix your smock.

ARTEMISIA

Yes, Daddy. *(leaves)*

TUTIA

Signore Gentileschi. *(starts to leave)*

ORAZIO

(grabs her arm) Give us a kiss. *(pulls her to him)*

TUTIA

No, Ratzo. This really isn't right.

> *ORAZIO kisses TUTIA.*

TUTIA

I'm very worried about Bella. She spends too much time alone.

ORAZIO

That's why you're here. *(continues kissing her)*

TUTIA

I have my family to look after. My baby.

ORAZIO

Want another one?

TUTIA

This is serious, Ratzo. Sometimes, I go by the studio and Bella's talking to herself. She's at that age. If you're not careful, she'll start to get fanciful.

ORAZIO

Fanciful?

TUTIA

Crazy.

ORAZIO

Oh come off it! My daughter's not crazy.

TUTIA

She has a very vivid imagination.

ORAZIO

That's good. Good for her art. *(starts undoing TUTIA's clothes)*

TUTIA

Is that all you ever think about! Art!

ORAZIO

No. I wouldn't say so. *(fondles TUTIA's breasts)*

TUTIA

It's not natural the way you're bringing up that girl. You're turning her into a freak.

ORAZIO

Bella has talent. Why shouldn't she be allowed to use it. *(buries his head in TUTIA's breasts)*

TUTIA

Frank and Carlo and Marcus might also have talent. Why don't you train them?

ORAZIO

(raises his head) That is beside the point. *(buries his head back in TUTIA's breasts)*

TUTIA

(grabs ORAZIO by the hair) What you've done is unnatural!

ORAZIO

All right. Let's be natural, then. *(hoists TUTIA over his shoulder and staggers over to a mattress in his studio)*

TUTIA

She should meet people her own age. She needs to be introduced to society. A party, or perhaps a ball.

ORAZIO

A ball's a fine idea. *(plunks TUTIA down)*

TUTIA

Is that a promise? You'll take her to a ball?

ORAZIO

Mmmm? Oh, all right. *(throws himself down on her)*

TUTIA

That's wonderful. You've made me very happy. *(heaves ORAZIO off her easily)*

ORAZIO

I could make you a lot happier.

TUTIA

You're sweet. *(runs out)*

SCENE 5

ORAZIO and TASSI.

ORAZIO

Be gentle with her.

TASSI

That might be difficult. She might not like it.

ORAZIO

Praise her paintings.

TASSI

If you think that would help.

ORAZIO

Oh yes—a little praise goes a long way with her. You see, she's not used to other men.

TASSI

I should hope not.

ORAZIO

Well, she's spent all her time with me so she only knows my style.

TASSI

Pardon me?

ORAZIO

I have a different way of doing things than you. I believe in giving lots of encouragement. I know you're more the bullying type. Don't bully her. She won't like it.

TASSI

Look don't tell me how to do my job.

ORAZIO

I'm sorry. I've interfered enough.

TASSI

It would probably be best if you went out for the whole day.

ORAZIO

The whole day? Is that necessary? *(pause)* I suppose it's better that I'm not around to distract. The first time will be the hardest. *(starts to leave—turns around)* I hope she likes you. *(leaves)*

 TASSI looks puzzled.

SCENE 6

The Studio.

TUTIA sits near the model stand.

TASSI
(enters, looks at TUTIA) Who are you?

TUTIA
Tutia. I live here.

TASSI
Not in the studio.

TUTIA
No. I live downstairs.

TASSI
Then, what are you doing in the studio?

TUTIA
Well—ah—to chaperone, of course.

TASSI
Why?

TUTIA
Well—a young girl always has a chaperone.

TASSI
When she goes out, yes. But in her own home?

TUTIA
I can't leave her alone with you.

TASSI

Did Signore Gentileschi ask you to stay?

TUTIA

Well, no. But he's very absent-minded. I'm sure he's expecting me to stay.

TASSI

Why? What do you think I'm going to do?

TUTIA

Well—it's not right.

TASSI

You think I'm going to seduce his daughter?!

TUTIA

Well—ah—

TASSI

THIS IS OUTRAGEOUS! I AM THE BEST FRIEND OF THE MAN WHO OWNS THIS HOUSE! THIS HOUSE THAT YOU HAPPEN TO BE LODGED IN!! AND YOU ACCUSE ME!!! *(splutters with rage)* I'm not getting paid for these lessons—you know. I'm only doing this out of friendship. I mean—you've seen the girl! REALLY! *(starts to leave)* Well, that's it! I'm leaving. You can tell Ratzo what you've done. And good luck. He's not very pleasant when he's angry.

TUTIA

(catches his arm) I'm sorry I offended you. Please stay and teach your class. I'll leave.

TASSI

You look tired. Orazio works people too hard. He probably has you up at all hours night and day.

43

TUTIA

Yes. He does.

TASSI

Orazio employs your husband, too?

TUTIA

No. He's in Tuscany looking for work.

TASSI

(ushers TUTIA out the door) You get some beauty sleep. If you were Orazio's daughter, it would be quite another matter.

TUTIA

(giggles) Oh now—

> *TASSI kisses her hand, and closes the door on her.*

Scene 7

The Lesson.

Agostino Tassi is in the studio. Artemisia enters.

ARTEMISIA

How do you do, Signore Tassi. *(curtseys; looks around)* Where s Tutia?

TASSI

No need to be so formal. I'm not your mathematics teacher. I'm your art teacher. And art is life. Is that not right?

ARTEMISIA

I don't have a mathematics teacher.

TASSI

Don't be so literal. Art is life. Would you agree with that?

ARTEMISIA

I hadn't thought about it.

TASSI

You should. Lesson No. 1: Think. Agostino. *(holds out hand)*

ARTEMISIA

Oh—I—ah—my father will think I'm being rude if I call you by your first name. Have you seen my chaperone?

TASSI

No. I haven't. Lesson No. 2: Your father is not the only man in the world. Here is another. *(holds out hand)* Agostino Tassi. And your name?

ARTEMISIA

You know my name. She should be here.

TASSI

Your name.

ARTEMISIA

Artemisia Gentileschi. But everyone calls me Bella.

TASSI

Give me your hand.

ARTEMISIA gives it reluctantly.

TASSI

(fondles hand) Artemisia. What a beautiful name.

ARTEMISIA

Yes, it's from the Greek goddess of the hunt. She—

TASSI

Yes yes, I know all that. Artemisia, you must learn that when a man says something nice, you don't suddenly talk his ear off. If someone gives you a compliment, take it. Because they're going to be few and far between. So—you say "Thank you." We'll try it again.

ARTEMISIA

Why should they be few and far between?

TASSI

You're no beauty.

ARTEMISIA

I'm not?

TASSI

No, of course not. You look shocked. You've been paying
too much attention to your father. Fathers see with
different eyes. Do you know why your father hired me?

ARTEMISIA

To teach me drawing.

TASSI

No. To teach you perspective.

ARTEMISIA

Yes. Drawing and perspective.

TASSI

Don't be sullen. Perspective isn't just drawing. It's a way
of looking at the world. Everyone agrees that they will
learn to look at the world in the same way and when you
learn to see the way everyone else does, then that's
perspective.

ARTEMISIA

I thought perspect—

TASSI

Parallel lines meet at the horizon.

ARTEMISIA

I thought parallel lines never met.

TASSI

As I said, I'm not your math teacher. That is one of the
rules of perspective.

ARTEMISIA

But it's wrong!

TASSI

You think you're very important. If you were standing in a
meadow 100 feet away from a man and he looked at you,
from his point of view you would be very small and not
important at all. That's perspective. So when I tell you
you're a big ugly girl, believe me. Because that also is
perspective. An objective point of view.

ARTEMISIA

Why are you so mean to me?

TASSI

I hate to see someone go through life deluded. Now, let's
look at some of your work. *(starts to pull "Susannah and the
Elders" out)*

ARTEMISIA

No! *(places herself in front of it)*

TASSI

Why not?

ARTEMISIA

I don't want to show you my work.

TASSI

Don't be spoiled. There are worse things in life than being
a big lump. Are you going to get out of my way or do I
have to move you myself.

ARTEMISIA remains standing.

TASSI

All right. *(grabs her and picks her up)*

ARTEMISIA struggles.

TASSI
(places her to one side) You're better looking with a bit of colour to your cheek. Don't get enough excitement at home. *(looks at painting)* I don't know why you didn't want me to see it. It's quite a good painting.

ARTEMISIA
I know it's a good painting.

TASSI
Is that a fact.

ARTEMISIA
Yes. It is. And if you don't mind, I'd like you to look at something else. *(goes to move it)*

TASSI
I do mind. And it's not as good as you think it is. The two Elders are ridiculously placed. They're almost on top of her. Wait a minute. You've changed his face.

ARTEMISIA
How would you know. You've never seen it before.

TASSI
(peers at it) And you've never seen me before. But if that's the case, why am I in your painting?

ARTEMISIA
That's not you!

TASSI
No? *(moves in closer)* Have you been spying on me, Artemisia?

ARTEMISIA

No.

TASSI

I'm flattered that you decided to immortalize me. I had no idea you found me that attractive.

ARTEMISIA

I don't. In my painting, you're an Elder.

TASSI

So, you work from life.

ARTEMISIA

Pardon?

TASSI

Well, that's me. I don't look at all old there. And that's your father. You've made him look old. And a bit dim, too. Do you think your father's stupid?

ARTEMISIA

Of course not!

TASSI

I think he's stupid. I wouldn't let a man like me near my daughter. So—if that's him and that's me, then that beautiful naked woman must be you. You look a lot better with your clothes off.

ARTEMISIA

That's not me!

TASSI

The face is yours and those hands are definitely yours. Huge. So, I presume the rest is you. Cowering in naked

splendour from those two old men. What are you afraid of, Artemisia?

ARTEMISIA

I'm not afraid of anything.

TASSI

You've painted me and your father as conspirators plotting against you. Do you really think your father lusts after you?

ARTEMISIA

Of course not!

TASSI

Why did you paint him that way?

ARTEMISIA

I just used his face. Stop reading meaning into it!

TASSI

What a beautiful body you have. The skin is milky. And that breast— *(runs finger along painting, looks at ARTEMISIA while he does so)* Exquisite. You're blushing, Artemisia.

ARTEMISIA

No, I'm not.

TASSI

Yes. You are. You see, the skin here has a rosy glow to it. *(runs finger along ARTEMISIA's cheek)* Not like the skin here. *(runs finger down and around her neck)* You've captured your skin tones very well. Oh. Blushing again. It's funny. You portray me as a man lusting after you and here I am, suddenly obsessed with your body. There is a power in your painting, Artemisia.

51

ARTEMISIA

Is there?

TASSI

You like it when I talk about your art. *(kisses her neck)*

ARTEMISIA

It's what you were hired to do.

TASSI

Maybe I was hired to do something else.

> *He kisses her passionately. ARTEMISIA is too surprised to resist.*
>
> *TASSI, still kissing her, puts his hand up ARTEMISIA's skirt.*
>
> *ARTEMISIA tries to push his hand away.*
>
> *They struggle. TASSI pins ARTEMISIA down and yanks her skirt up.*

ARTEMISIA

NO! *(struggles; screams)*

TASSI

(claps hand over her mouth) Your father's left you here alone. Surely that should tell you something.

> *ARTEMISIA bites his hand.*

TASSI

OW! *(loosens his grip on ARTEMISIA)*

ARTEMISIA tries to get away. TASSI grabs her, stuffs a paint rag in her mouth, pins her down and rapes her.

Lights down.

Scene 8

Artemisia curled up in a ball to one side. She rocks back and forth. The door rattles.

Artemisia looks up in terror.

TUTIA

(off) Bella? Are you in there? The door's locked.

Artemisia stares at the door.

A key turns in the lock.

Tutia rushes in, looks around, does not initially see Artemisia, turns to leave and sees her.

TUTIA

Bella?

Artemisia stares at her.

TUTIA

Bella, are you all right? *(goes over to her, sees her clothes are torn, etc.)* Oh my God! That bastard! That bloody bastard!

ARTEMISIA

(quietly and without emphasis) Where were you? Why weren't you here?

TUTIA

(embraces Artemisia) Oh, you poor dear. It must have been awful. Did it hurt?

Artemisia nods.

TUTIA

(*fusses over* ARTEMISIA's *clothes*) Your beautiful new dress.

ARTEMISIA *stares mournfully at* TUTIA.

TUTIA

Now, don't worry, we can fix it. You didn't encourage him, did you?

ARTEMISIA *looks blank.*

TUTIA

Smile at him? Flirt with him?

ARTEMISIA

First he told me I was ugly. Then he started kissing me.

TUTIA

You let him kiss you?!

ARTEMISIA

Romeo kisses Juliet.

TUTIA

Romeo is going to marry Juliet. Did he say anything about marriage before he started kissing you?

ARTEMISIA

He said he was obsessed with my body.

TUTIA

That's it?

ARTEMISIA *nods.*

ORAZIO *can be heard offstage.*

ORAZIO

(off) Bella!

TUTIA & ARTEMISIA *(TOGETHER)*
(TUTIA) Oh my God! *(rushes up and locks the door.)*
(ARTEMISIA) He can't see me like this!

TUTIA

Ssssh.

ORAZIO

(at door) Bella? Are you in there?

TUTIA

Bella's downstairs.

ORAZIO

Oh. *(sound of footsteps walking away)* Bella?

ARTEMISIA

I'll have to tell him.

TUTIA

No! *(pause)* He'll go after Tassi and Tassi will say you
encouraged him and it'll be your word against his and
believe me, that man has a mouth on him. God! He's
probably telling people now.

ARTEMISIA

What am I going to do?

TUTIA

(paces) If only I'd caught him! We could have forced
him to marry you.

ARTEMISIA

I don't think I'd want to marry him.

TUTIA

You could have been engaged and then broken it off.

ARTEMISIA

But why?

TUTIA

He wouldn't tell people his fiancée's a whore.

ARTEMISIA

Oooh.

TUTIA

But it's too late. I wasn't there. *(pause)* Unless, of course, it happens again. Was it only the one lesson your father arranged?

TUTIA and ARTEMISIA exchange a conspiratorial look.

SCENE 9

TASSI's apartment.

A young girl lounges in a chair in the room.

TASSI enters, exhausted. He looks up, sees the girl and gives a start.

> TASSI

Lisa?

> LISA

Surprised to see me.

> TASSI

Well—you're—ah—married now.

> LISA

That old fart. He can't get it up more than once a day.

> TASSI

Does he know where you are?

> LISA

Of course not. I've gone out.

> TASSI

He might guess.

> LISA

When did you become so cautious?

> TASSI

I'm tired of lawsuits.

LISA

You forgot my birthday and I want my present. *(smiles and advances on him)*

TASSI

How old are you, now? Sixteen?

LISA

Fourteen. You know exactly how old I am.

TASSI

You seem older.

LISA removes a stocking.

TASSI

I had a very interesting day, today.

LISA

(not interested) Really.

TASSI

I met a young girl who was entirely innocent.

LISA

What a bore. *(removes other stocking)*

TASSI

A frightening experience. Not a bore at all. She was like a large child.

LISA

Like me?

TASSI

You were never a child.

LISA

She won't be innocent for long.

TASSI

I don't know why you have such a low opinion of me.
Anyway, her father hired me to seduce her.

LISA

What father in his right mind would do that!

TASSI

He's not in his right mind. He's an artist.

LISA

He probably wants you to marry her.

TASSI

I don't think so. He knows me too well.

LISA

It might be a trap. He might be planning to catch you at it.

TASSI

No. That doesn't make sense. *(pause—starts to laugh)*

LISA

What's so funny?

TASSI

Well—he was fairly cryptic in his request. *(laughs)* I
mean—it is possible that he simply wanted me to teach
her perspective. *(laughs)* We were both pretty drunk. Oh
my God! *(hysterical laughter)*

LISA

What happened to your hand?

TASSI

Occupational hazard.

LISA

Here. I'll kiss it all better. *(starts to kiss his hand)*

TASSI

No—Lisa—really. Stop. I'm not in the mood. *(breaks away)*
Don't you feel any remorse at all about your sister?

LISA

No. I hated her. She was a bitch. Did you really kill her?

TASSI

I hired someone.

LISA

Oh. That doesn't count.

TASSI

She's dead, isn't she.

LISA

Yes, but it would have been better if you'd done it
yourself.

TASSI

I'm sorry.

LISA

That's all right. Let's make love, now.

TASSI

It's not true, you know.

LISA

What.

TASSI

I didn't murder your sister. I didn't hire anyone, either.

LISA

I don't care.

TASSI

I know. *(pause)* Fascinating.

LISA

Don't get so high and mighty with me. You wanted her dead. You might as well have killed her.

TASSI

There's a huge gulf between the desire and the action.

LISA

It's too late to tell me that. *(removes clothes)*

TASSI watches her, sighs.

LISA shoves TASSI onto the bed.

A loud knocking on the door.

TASSI and LISA sit bolt upright.

TASSI & LISA *(TOGETHER)*

(TASSI) Your husband!
(LISA) My husband!

TASSI pushes LISA out of bed, grabs her clothes and shoves her out of a side exit. More knocking.

TASSI opens door in a nonchalant fashion.

ORAZIO stands in the doorway.

TASSI

Shit. *(tries to close door)*

ORAZIO

(walking in) That's not much of a greeting. We didn't set a time for the next lesson.

TASSI

Another one?

ORAZIO

Yes. My daughter wants you back.

TASSI

Pardon?

ORAZIO

She says you haven't begun to teach her what she needs to know.

TASSI

She didn't really say that, did she?

ORAZIO

Yes. It's a little insulting, you know, Tassi.

TASSI

This is extraordinary.

ORAZIO

I mean, I think I'm a pretty good teacher. But, I suppose she's right. There's no point in only one class. What did you cover?

TASSI

Oh—ah, one-point perspective. And worm's-eye-view. We explored that thoroughly.

ORAZIO

Then, you've got two-point and bird's-eye for the next lesson. Creating forms in space for the third.

TASSI

She's probably well on her way to creating a form in space.

ORAZIO

She couldn't do it without you, Tassi. Same time next week, then. *(claps him on the back and leaves)*

Scene 10

The Studio.

Artemisia is wearing a very provocative dress.
She looks very intent as though about to
perform some secret rite.

Artemisia

"Judith prayed to God to give her strength to defeat
 Holofernes.
Bring to pass, O Lord, that his pride may be cut off with
 his own sword.
Let him be caught in the net of his own eyes in my regard
 and do thou strike him by the graces of the words of my
 lips.
Give me constancy in my mind that I may despise him
 and fortitude that I may overthrow him.
For this will be a glorious monument for thy name, when
 he shall fall by the hand of a woman."

> *She squirts perfume all over herself, puts on too*
> *much makeup and fixes her hair while she*
> *speaks.*

"And she washed her body and anointed herself with the
 best ointment and plaited the hair of her head. *(tries to
 plait hair, gives up and lets it fall loose)*
And clothed herself with the garments of her gladness and
 put sandals on her feet and took her bracelets and lilies
 and earlets and rings and adorned herself with all
 ornaments."

> *She puts masses of jewelry on and looks at*
> *herself in the mirror.*

"And the Lord also gave her more beauty: because all this dressing up did not proceed from sensuality but from virtue.
And therefore, the Lord increased this her beauty so that she appeared to all men's eyes incomparably lovely."

ARTEMISIA stands as though in a trance.

Lighting changes for "Judith" scenes.

SCENE 11

HOLOFERNES' camp. HOLOFERNES (TASSI) and RATZO.

RATZO

It's about that Hebrew woman, sire.

HOLOFERNES

Yes—why hasn't she been brought to me? Why am I always the last person to know?

RATZO

I asked them not to. Not till I'd spoken to you first.

HOLOFERNES

You've got your nerve!

RATZO

Sire, I'm not subject to female charms and—

HOLOFERNES

Why not. Being a eunuch shouldn't deprive you of an aesthetic sense.

RATZO

I mean—sire—I don't trust this woman. She claims that she will help us conquer her town. Now, why would she do that. She's got this cock-and-bull story about how her god is angry at her people and wants to punish them.

HOLOFERNES

Why is her god angry?

RATZO

Oh—I don't know—they've been eating the wrong food.
She's eating the right food. She will lead us straight to her
people and as long as she eats the right food, it's okay.

HOLOFERNES

It sounds ridiculous.

RATZO

It is ridiculous. But the problem is—everyone believes her.

HOLOFERNES

Why?

RATZO

She's very beautiful, sire. She's got them all charmed. And
when she tells her story, for some weird reason, it sounds
convincing. I think it would be best if you didn't see her.

HOLOFERNES

Send her in.

RATZO

But sire—

HOLOFERNES

Don't tell me what to do. Send her in!

RATZO leaves and brings in JUDITH.

SCENE 12

HOLOFERNES and JUDITH. JUDITH enters and prostrates herself before HOLOFERNES.

JUDITH

My lord.

HOLOFERNES

You are the Hebrew woman from Bethulia?

JUDITH

(still prostrate) Yes, my lord.

HOLOFERNES

And you choose to serve Ozymandias?

JUDITH

Yes, my lord.

HOLOFERNES

You may rise. What's your name?

JUDITH

(rises, looks at HOLOFERNES) My name is Judith, my lord.

HOLOFERNES

You're trembling. Don't be afraid. I've never harmed anyone who chose to serve Ozymandias. Simply those who defy him. Your people would have been safe if they hadn't insulted us. Give me your hand.

JUDITH does so reluctantly.

HOLOFERNES

People have to meet me halfway. You're not ready yet, are you?

JUDITH

I don't understand, my lord.

HOLOFERNES

(drops her hand) Later. If you're such a devout Hebrew, how do you plan to serve both gods?

JUDITH

I worship Jehovah in Heaven and Ozymandias on earth.

HOLOFERNES

A clever answer. You're very shrewd.

JUDITH

But it is the truth, my lord. I swear by Ozymandias it is so. May he strike me dead if I lie.

Pause.

HOLOFERNES

Then again, if you don't believe in him, he couldn't strike you dead, could he?

JUDITH

That's blasphemy, my lord.

HOLOFERNES

Not really. Ozymandias is simply the king who rules Ninevah. He'd like to be worshipped and so as part of my job, I worship him. The other part of my job is that I have to make everyone else worship him. That is more difficult.

JUDITH

So, you don't really believe Ozymandias is a god?

HOLOFERNES

Given the choice, I prefer my gods to be invisible. Visible gods have an annoying habit of thinking up things for me to do. But you still haven't answered my question. How can you betray your god?

JUDITH

I am not betraying Him. He is very angry with my people. They are planning to break into the forbidden food supplies. Jehovah has sent me to punish them through you.

HOLOFERNES

Is food that important?

JUDITH

Yes.

HOLOFERNES

Does this god—this Jehovah—does he actually talk to you?

JUDITH

Yes. He gave me a prophecy. "I am to do things with you that will be the wonder of the world wherever men hear about them."

HOLOFERNES

Hmmm. *(smiles)*

JUDITH

I am to stay in your camp and each night before dawn, I am to go out into the valley and pray to Jehovah.

HOLOFERNES
I don't think you should go out alone.

JUDITH
My maid can come with me, then. Jehovah will tell me
when my people have committed this sin. Then I will
return and you may lead out your whole army and you
will meet with no resistance. They will follow you like
sheep. We will set up your throne in the heart of
Jerusalem.

HOLOFERNES
If you do as you have promised, Jehovah shall be my god
as well. *(to RATZO)* Food and drink for our guest!

JUDITH
I'm afraid I can't eat your food, my lord. If I broke my
food vow, Jehovah would not talk to me. I have my own
provisions. *(indicates basket)*

HOLOFERNES
It isn't much. What if you run out? *(motions for RATZO to
leave)*

JUDITH
I won't run out until I have done what my Lord has
planned.

HOLOFERNES
That sounds sinister.

JUDITH
I only meant, my lord, that together, you and I will
accomplish a great deal very quickly.

HOLOFERNES
Then, let us begin tonight! *(pulls her onto the bed)*

JUDITH

My lord!

HOLOFERNES

Oh stop calling me that! *(kisses her)*

JUDITH

(struggling) No! Please! You must stop!

HOLOFERNES

(stops) You have nothing to fear from me, Madame. I didn't know you found me so unattractive.

JUDITH

I admire you a great deal, my lord. Still, everything must come at its appointed time.

HOLOFERNES

When's that? Doomsday.

JUDITH

Soon. My lord, will you give orders for me to be allowed out each day before dawn? That is the best time for me to talk to Jehovah.

HOLOFERNES

Very well. *(claps hands)*

> *RATZO enters.*

HOLOFERNES

Ratzo, please conduct the Hebrew woman to her tent. She will go to the guards before dawn and ask to be allowed out to pray. Tell the men to let her pass.

> *RATZO gives HOLOFERNES a questioning look and leaves.*

JUDITH

Thank you, my lord. *(bows)*

HOLOFERNES withdraws.

Lights change.

TUTIA enters.

TUTIA

Whew! What's that stink!

ARTEMISIA

Perfume. Don't you ever knock.

TUTIA

Christ, what's happened to you. You look like a slut.

ARTEMISIA

What?

TUTIA

Bangles up to your elbows. *(removes them)* Do up your
bodice. *(starts hoisting up dress)* Your breasts are about to
fall out.

ARTEMISIA

I'm supposed to seduce him, aren't I?

TUTIA

Seduce him?! You'll scare the living daylights out of him.
Wash your face.

ARTEMISIA

He'll be here any minute.

TUTIA

I don't care. Wash your face.

ARTEMISIA washes makeup off.

TUTIA

Are you sure you want to go through with this?

ARTEMISIA

Yes.

TUTIA

You seem pretty nervous.

ARTEMISIA

He's late! Why isn't he here yet?

TUTIA

Maybe he's not coming. Maybe we should just leave well enough alone.

ARTEMISIA

But this was your idea!

TUTIA

He might not have told anyone. And if there're no repercussions.

ARTEMISIA

Repercussions?

TUTIA

Babies.

ARTEMISIA

Oh my God!

TUTIA

Yes. I meant to mention that. You've got long fingers so that's a good sign.

ARTEMISIA

Pardon?

TUTIA

Women with long fingers don't get pregnant as easily as women with short fingers. But then again, there's the element of surprise. You weren't expecting it. And somehow, those are the ones that usually take. When was your period?

ARTEMISIA

Two weeks ago.

TUTIA

Oh my God! Not today! Bolt the door!

ARTEMISIA

What?!

TUTIA

Bad day today. Definitely not the day!

Knocking at door.

TUTIA races up to bolt the door. ARTEMISIA pulls her back.

ARTEMISIA

No! He started it and I'm going to finish it.

She opens the door and curtseys to TASSI who walks in.

ARTEMISIA

Signore Tassi.

TASSI

Signorina Gentileschi. And Signora Liotta. *(bows)*

ARTEMISIA

So, Tutia, if you hurry, you'll be able to catch up with father. Tell him we're running low on burnt sienna, please.

TUTIA

Oh, all right. *(leaves)*

TASSI

So, you've asked me back for a command performance. Anything special you'd like me to do?

ARTEMISIA

Um—ah—you're the teacher. You should decide what I need to learn next.

TASSI

How delightfully ambiguous. Are you suggesting what I think you are?

ARTEMISIA

Perhaps.

TASSI

Well, forget it. It won't happen again.

ARTEMISIA

It won't?

TASSI

No. There are some duties in life that are simply too onerous.

ARTEMISIA

Onerous?

TASSI

Too much hard work.

ARTEMISIA

Raping me was hard work?!

TASSI

Damn right it was. Look at my hand. It still hasn't healed.
I think you should apologize.

ARTEMISIA

I should apologize?!

TASSI

I'm waiting.

ARTEMISIA lunges at him, rips his shirt.

TASSI

Hey! Don't rip my clothes. How'd you like it if I ripped
your dress.

ARTEMISIA

Just try it! I dare you! You snivelling little pimp!

TASSI grabs her bodice and tears it open.

*ARTEMISIA grabs TASSI's belt and tries to pull
his pants down.*

TASSI

WHAT THE HELL!

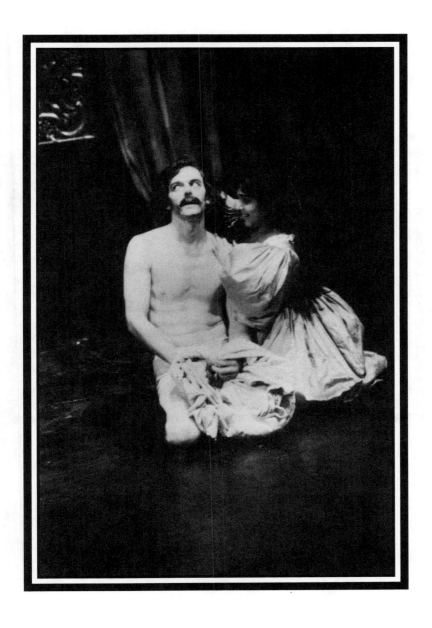

Tom McCamus as TASSI *and Pamela Sinha as* ARTEMISIA. *Photo by David Lee.*

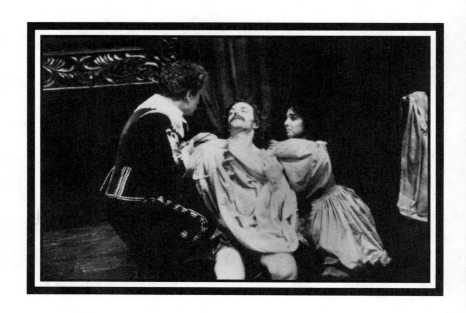

Benedict Campbell as ORAZIO, *Tom McCamus as* TASSI *and Pamela Sinha as* ARTEMISIA. *Photo by David Lee.*

They struggle and fall on the ground.
ARTEMISIA works it so TASSI is in a very
compromising position.

ARTEMISIA

Perfect! *(grabs TASSI and won't let him get away)* H
HELP! RAPE!! DADDY!! DADDY!!

TASSI

Holy Jesus! *(struggles to get up)*

> *ARTEMISIA clamps on to him and screams.*
> *ORAZIO and TUTIA rush in. TUTIA is carrying a*
> *broom.*

ORAZIO

Oh my God! *(crosses himself)*

> *TUTIA hits TASSI with broom.*

TASSI

OW! *(dodges blows)* Fine! I'll leave. *(rushes to door)*

ORAZIO

(bolts door) YOU B-A-A-A-STARD.

TASSI

It's not what you think. She set it up.

ORAZIO

Who? My daughter?! LIAR!! *(grabs TASSI's throat; pulls out knife)*

TASSI

Sorry. Didn't mean that.

ARTEMISIA

Don't kill him, Daddy.

ORAZIO

Why not?

ARTEMISIA

He did propose to me.

TASSI & ORAZIO

WHAT?!

ARTEMISIA

And I accepted.

TASSI

Jesus! *(puts head in hand)*

ORAZIO

(lets TASSI go) Oh, Bella, how could you!

ARTEMISIA

He is a friend of yours, Daddy, and he said he loved me
very much and we'd have one of those old-fashioned
engagements. Nozze di riparazione.

TUTIA

Marriage by capture. It's all the rage now, sir.

ORAZIO

(to TASSI) Is this true?

TASSI

Well—there is my wife.

ORAZIO

(draws knife) You said she was dead.

TASSI

Yes, of course, I did, didn't I. Well—I'm sure she is. Dead, that is. *(to ARTEMISIA)* Is this a long engagement?

ARTEMISIA

Yes.

TASSI

Well—if she isn't dead now, one of us will be by the time I marry your daughter. *(laughs uneasily)*

ORAZIO

You're such a kidder.

TASSI

Joke's on me this time, Ratzo. I really don't deserve your daughter.

ORAZIO

Come, let's celebrate! Put your clothes back on and we'll grab a bottle of my best wine and drink! To marriage by capture!

ARTEMISIA

Yes! To marriage by capture!

END OF ACT ONE

ACT TWO

SCENE 1

Six months later.

The Studio.

TASSI is sprawled out on the studio mattress in the "Holofernes" pose. His shirt is off and he has fallen asleep.

ARTEMISIA enters, quietly, so as not to wake him. She sees a sword hanging on the wall. She very carefully takes it down from the wall.

TASSI

Mmmmm. *(moves slightly)*

ARTEMISIA freezes.

She waits for a few moments, then goes over to TASSI. She lifts the sword up and poises it over TASSI's throat.

TASSI

(wakes up, sees ARTEMISIA) HOLY CHRIST!

He raises his arm and grabs ARTEMISIA's sword hand. He makes her drop the sword.

ARTEMISIA

Oh sorry, I was just thinking.

TASSI

Do you have to do it with a sword at my throat! JESUS!

ARTEMISIA

It won't work. She won't be able to do it on her own. She'll need the maid. Let's see now. Lie back again. *(picks up sword)*

TASSI

GET THAT FUCKING SWORD AWAY FROM ME!

ARTEMISIA

Did I frighten you?

TASSI

NO! *(pause)* I'm just not used to waking up with a sword at my neck, held by a woman with a very intent look on her face. Call me crazy, but it makes me nervous. What's this for, anyway?

ARTEMISIA

I'm doing a painting of Judith.

TASSI

And I'm Holofernes?

ARTEMISIA nods.

TASSI

OH NO! THAT'S IT! NOT ME! I hate that story. You're not using my face! *(goes over to drawing)* Doesn't even look like me. *(tears drawing in half)*

ARTEMISIA gasps.

TASSI

(throws pieces on the floor) You're not putting me in that painting and that's final!

ARTEMISIA

What right have you to—

TASSI

(puts on shirt) I'm your fiancé. Love, honour and obey.

ARTEMISIA

But—

TASSI

Christ! You shouldn't have let me sleep so long. We gotta go!

ARTEMISIA

Where? What are you talking about?

TASSI

Picnic. Do your bodice up. I don't want my friends to think I'm marrying a slut. *(kisses her and leaves)*

> ARTEMISIA *straightens her clothes. As she is about to leave, she grabs pieces of her drawing, rolls them together and hides them under the bed.*

SCENE 2

THE PICNIC.

ARTEMISIA, TASSI, COSIMO QUORLI,
GIAMBATTISTA STIATTESI, LISA and her husband
who, shall be referred to as OLD MAN.

OLD MAN
This liver isn't chopped fine enough. It's got gristly bits that catch in my teeth.

LISA
Poor baby. I didn't know you still had teeth.

OLD MAN
(smiles beneficently at her) Ah, my love. So, you will get the butcher to grind it finer in the future.

LISA
Certainly, my dove.

OLD MAN
Excuse me a moment. My digestion is not what it used to be. *(leaves)*

LISA
Ground glass.

ARTEMISIA
What?

LISA
(ignores her; to TASSI) The glass isn't working. Maybe, I've ground it too fine. But if it were bigger, he'd see it.

GIAMBATTISTA coughs, splutters.

LISA
Oh, don't worry. Once in a while does no harm at all.

COSIMO
(to ARTEMISIA) You've got great tits.

ARTEMISIA blushes, looks away.

COSIMO
Well, ya do. She's got great tits, Tassi. Who'd have thought my daughter would have great tits.

ARTEMISIA
Your daughter?

COSIMO
Hey, Giambattista, don't you think we look alike?

GIAMBATTISTA
No.

LISA
She's got your hairy arms, Cosimo.

ARTEMISIA looks at her arms.

LISA
Trust me. They're hairy. How can you stand it, Tassi. She looks like a gorilla.

TASSI
I think hairy arms are very attractive.

LISA
Does she have hair all over her stomach, too?

TASSI

(warningly) Lisa.

COSIMO

(to ARTEMISIA*)* Do you? *(strokes* ARTEMISIA*'s arm)*

ARTEMISIA

Please. Take your hands off me.

COSIMO continues mauling her.

ARTEMISIA

Agostino.

TASSI

Yes, Artemisia.

ARTEMISIA

Please.

COSIMO

But I'm his best man. We share everything.

LISA

She really is bourgeois, isn't she. *(to* ARTEMISIA*)* Shall I
spell it out for you. I love Cosimo. *(kisses him)* and
Cosimo loves me. I could love Giambattista but he won't
let me and I'm very very good friends with Agostino here.
We were better friends until you came along. But you
see—those bourgeois principles of yours—one man, one
woman—well, it's very divisive. Isolating yourselves in a
little cocoon. What about the rest of the world?
Giambattista here. Now, he loves Agostino. And what sort
of man would Agostino be if he didn't return that love
from time to time. You're being very selfish, Artemisia.
You want Agostino all to yourself. And that's wrong.
We're all one big loving family here.

OLD MAN enters.

LISA

Except for him.

OLD MAN

Did I miss something?

LISA

No, darling. Why don't you have a nice little nap and when things get exciting, I'll wake you up.

OLD MAN

All right. *(lies down to sleep)*

LISA

Bad heart. Can't take the strain of my lifestyle but he likes to watch.

ARTEMISIA

(to TASSI) Is this true?

TASSI

He's an old man.

ARTEMISIA

No. Her. This man. *(gestures to GIAMBATTISTA)*

GIAMBATTISTA

Agostino and I were once lovers. Does that disturb you?

ARTEMISIA

Yes!

LISA

How small-minded of you.

TASSI

(to ARTEMISIA) I thought you wanted to be an artist.

ARTEMISIA

Yes, but what does this—

TASSI

Then, you have to explore your senses. You have to experience life to the fullest. You can't remain on the outside, forever. Innocence can only take you so far. You want to be a great painter, don't you.

ARTEMISIA

What if I wind up like her.

LISA

What's wrong with me!

TASSI

You might. That's a risk you have to take.

LISA

What the hell's wrong with me!

COSIMO & TASSI

Nothing, dear.

OLD MAN wakes up and stares at ARTEMISIA.

OLD MAN

Say, are you related to Orazio the painter?

LISA

Quick off the mark, as always.

ARTEMISIA

Yes. I'm his daughter.

 COSIMO
No. You're my daughter!

 OLD MAN
(astonished) Sonofabitch!

 ARTEMISIA
Pardon?

 OLD MAN
I was supposed to marry you. Your name's Bella, right?

 ARTEMISIA
That's my father's name for me. Yes.

 OLD MAN
Your father said you weren't ready, yet. You look pretty
ripe to me. That's fruit's been plucked, eh Tassi. *(nudges
him)*

 ARTEMISIA
My father would never arrange such a thing.

 OLD MAN
Which? Marrying me or getting plucked. Not to be rude,
Missy, but I think he arranged both. You don't put a cat
like Tassi with your prize pigeon without expecting to lose
a few feathers. *(chortles away)*

 GIAMBATTISTA
Have some more chopped liver.

 OLD MAN
Oh—now—I've had plenty. *(eyes ARTEMISIA up and down
lasciviously)* Well—now, isn't that interesting. That's two
you've stolen from me, Tassi. Oh well, better to lose this

 93

one right away than to marry her and then lose her. Maybe, I'll try and steal her back.

LISA

Why don't you go back to sleep, dear.

OLD MAN

DON'T TELL ME WHEN TO FALL ASLEEP.

ARTEMISIA

That's not true what you said about my father! He's not like that!

COSIMO

Yeah, I've got better taste than that.

OLD MAN

He's a friend of Tassi's. What do you expect.

ARTEMISIA

He'd never do those things!

TASSI

Your father's a hypocrite. It's fine for him and it's fine for me, but it's not all right for you. You're supposed to be purer than pure—good as gold. Why do you have to maintain a standard of virtue. Nobody else does. Least of all your father. *(snickers)* Ha! The bordellos he's dragged me into—grungy little hovels—whores with names like Black Maria and Spanish Flea. Lately, he's come up in the world. Tutia's quite respectable.

ARTEMISIA

Stop! Stop this! It's not true!

GIAMBATTISTA

Agostino, stop. I think she's had enough.

TASSI

(to ARTEMISIA) You can flirt with danger but you can't live
with it. When I told you life was art—you thought I was
being facetious. I am in deadly earnest.

ARTEMISIA

I can't live this way.

TASSI

Then you'll never be great. You have to live on the edge to
be great.

LISA

Like Caravaggio.

TASSI

Like Caravaggio!

ARTEMISIA

(to TASSI) Why aren't you great, then?

GIAMBATTISTA

She's direct.

TASSI

I am. It's not my fault if the world at large hasn't heard of
me.

ARTEMISIA

She's a great painter, too, I suppose.

TASSI

Lisa is one of my best pupils, aren't you, dear?

LISA

Yes. I'm very good. In fact, I have some drawings I'd like
you to look at. Privately.

TASSI

Perhaps, later.

LISA

No. I want you to look at them now. I need help with my foreshortening. *(to ARTEMISIA)* Have you had that lesson, yet? It's one of his best. Although the Introduction to Perspective is interesting. "If I were a man standing 100 feet away from you—"

TASSI

Hem! *(tries to take her off)*

LISA

Gets them every time.

LISA leaves with TASSI.

COSIMO

Well, how bout it?

ARTEMISIA

How bout what?

COSIMO

How bout a little kiss for your old dad.

GIAMBATTISTA

Lay off her, Cosimo.

COSIMO

Lisa said—

GIAMBATTISTA

I don't care what Lisa said. Lay off her!

COSIMO

Easy for you to say. Women aren't your special interest group. He gets paid. I do it for pleasure.

OLD MAN

It's a pity we missed each other, my dear. You have just the right amount of spunk. Lively—yet not vicious. Lisa has a bit too much spunk for my taste. What enormous hands you have. *(takes one of ARTEMISIA's hands)*

COSIMO

Yes—they are rather large, aren't they. *(takes the other)*

> *The two men exchange glances. ARTEMISIA tries to snatch her hands away. She is still held by the two men. GIAMBATTISTA pulls out a knife and advances on COSIMO who promptly drops ARTEMISIA's hand. The OLD MAN also backs off. TASSI enters, with LISA.*

TASSI

That won't be necessary. *(goes over to ARTEMISIA)* My darling, I think it's time we went home.

OLD MAN

(to ARTEMISIA) I'll have you on canvas, then.

> *ARTEMISIA and TASSI start to leave.*

OLD MAN

You too, Tassi. In fact, you're the reason for the painting.

TASSI

Ratzo's painting?

OLD MAN

You've seen it, then. I wanted your head, Tassi, and Ratzo
volunteered to paint it for me. Salomé, John the Baptist,
head on a platter. Not too subtle but it suited my mood.
But Ratzo couldn't bear to paint his little Bella as a
temptress. So, he suggested Judith.

TASSI

Why that little shit.

OLD MAN

There's nothing he wouldn't do for a buck. He must be
finished it by now.

TASSI

(to ARTEMISIA) Your father mention anything about a
dowry?

ARTEMISIA

No.

OLD MAN

Are you kidding?! You won't get a dowry from Ratzo. He
wouldn't give me one.

TASSI

How much did he want for the painting?

OLD MAN

Well, he wanted the world but I talked him down.

TASSI

How much?

OLD MAN

Three hundred ducats.

TASSI

I'll sell it to you for two hundred.

OLD MAN

I hate to cheat a friend.

TASSI

It's my head. And my fiancée. I'm entitled to a dowry.
Don't you agree, my dear?

ARTEMISIA

Oh—ah—I don't know—

TASSI

We'll deliver it tomorrow night.

OLD MAN

I wouldn't want to start a quarrel.

TASSI

I'm only taking what's rightfully mine. *(leaves with
ARTEMISIA)*

Scene 3

Artemisia and Tassi. They are lying on a bed.

ARTEMISIA
You're trying to make a whore of me.

TASSI
It's just a lifestyle. You take things so seriously.

ARTEMISIA
I couldn't sleep with those men. Never.

TASSI
You don't have to. You can live exactly the way you like.

ARTEMISIA
And you?

TASSI
I live the way I like.

ARTEMISIA
Have you—ah—slept with all those people?

TASSI
Not the Old Man. I don't think anyone sleeps with the Old Man. Not even Lisa.

ARTEMISIA
Who does Lisa sleep with?

TASSI
Whoever's around, I imagine.

ARTEMISIA

Were you ever—around?

TASSI

You're not going to be jealous, are you? That would be
very boring. You can't own people, Artemisia. I love you
but I can't guarantee that I'll always be faithful to you.
Anymore than you can.

ARTEMISIA

But you're faithful to me now?

TASSI

More or less.

ARTEMISIA

Which is it?

TASSI

Let's not be tedious. Nobody's perfect. Not me. Not you.
Not even your father.

ARTEMISIA

I don't like what you said about my father.

TASSI

Can't help it. It's true.

ARTEMISIA

Did he really ask you to rape me?

TASSI

Rape is an ugly word. And misleading. *(undoes her bodice)*

ARTEMISIA

Did he?

TASSI

He knew the sort of man I was. Anyway, you should be honoured.

ARTEMISIA

Pardon?

TASSI

He's treated you like a son. He's taught you his craft and now, he wants you to live like a man.

ARTEMISIA looks puzzled.

TASSI

On my twelfth birthday, my father bought me the services of his favourite whore. His tastes ran to over-ripe women, so it wasn't exactly a pleasant experience. But it was necessary.

ARTEMISIA

Why?

TASSI

It's a fact of life. Women never get a proper introduction to the facts of life. Your father has done you this immense service and you don't even appreciate it.

ARTEMISIA

He's been lying to me my whole life!

TASSI

I told Ratzo it was a waste of time to train you. Women will never be as clear-headed as men. I fucked the whore but I didn't marry her. You want to marry the whore.

ARTEMISIA

The whore? *(pause)* Or the pimp.

TASSI

(looks at her sharply, then stops himself) You act as though
life is a personal affront. I simply follow my instincts.

ARTEMISIA

Like a dog.

TASSI

Yes. Like a dog. *(fondles her)* I see my master's linen, lying
on a bed. White and newly starched. I creep up, grab a
crisp white corner in my mouth. *(grabs ARTEMISIA's sleeve
with his mouth)* And I pull. Gently at first. *(tugs at sleeve)*
And then, I yank it. *(pulls her on to the floor)* Off the bed
and I roll around in it. I roll around and around—

> ARTEMISIA *and* TASSI *roll around on the floor.*
> ARTEMISIA *starts giggling.*

TASSI

And around and around. *(stops; he is on top of her)*
Imbuing it with my scent until it's mine.

> *They kiss.*

SCENE 4

The Studio.

ORAZIO is pacing back and forth.

ARTEMISIA enters and walks by him.

ORAZIO
(blocks her path) You didn't come home last night.

ARTEMISIA
So. *(tries to get by)*

ORAZIO
(stops her) You ditch your chaperone—you go out on this picnic and you disappear for the night.

ARTEMISIA
(pulls away) I'll live as I please.

ORAZIO
Not in my house, you won't!

ARTEMISIA
Then, I'll live with Agostino.

ORAZIO
NO! You can't stay at his house. Not till you're married. It looks bad.

ARTEMISIA
Why? It makes me look like a whore?

ORAZIO
Don't say that word!

ARTEMISIA

Why not? You sell me to the highest bidder. I might as well be one. Maybe Spanish Flea will lend me some of her clothes.

ORAZIO

Who?

ARTEMISIA

You know Spanish Flea, Daddy.

TUTIA enters.

ORAZIO

No. Of course, I don't.

ARTEMISIA

LIAR! HYPOCRITE!!

ORAZIO

Bella!

TUTIA

I'm sure she doesn't mean it, Signore. Young girls are very excitable.

ARTEMISIA

Shut up, you bitch!

TUTIA gasps.

ORAZIO

You apologize to Tutia!

ARTEMISIA

NO! Ask her why she wasn't at the picnic.

TUTIA

I didn't know you were going! Little Julio had colic and was screaming his lungs out. So, it's not as if I spent a pleasant Sunday—

ORAZIO

A misunderstanding, then. In future, Tutia, please accompany them.

TUTIA

Yes, Signore.

ARTEMISIA

(disgusted) Oh spare me the Signore act. You two were probably having it off.

TUTIA

WHAT?!

ORAZIO

Hem! Who was with you on this picnic?

ARTEMISIA

All your friends, Daddy. That horrible old man you tried to sell me to—

ORAZIO

Pardon?

ARTEMISIA

The man who commissioned the Judith painting.

ORAZIO

Oh yes—have you seen it? I can't find it, anywhere.

ARTEMISIA

Who else was there? The old man's wife—Lisa. I guess she beat me to it. Giambattista, Cosimo—

ORAZIO

Cosimo?! He's a sex-fiend. You spent the afternoon with him?!

ARTEMISIA

I spent the afternoon with all of them, Daddy. Individually and all at once.

ORAZIO

WHAT!

ARTEMISIA

Agostino says it's the way you live. So why shouldn't I try it. Like father, like daughter.

ORAZIO

WHAT! These are lies! That bastard! I'll—

ARTEMISIA

At least, he doesn't pretend to be something he's not. After years of lies, it's nice to meet an honest man.

ORAZIO

HONEST?! ARE YOU CRAZY! Bella—you must believe me.

ARTEMISIA

You go with him on his whoring. Tell the truth.

ORAZIO

Well. *(looks at* TUTIA*)*

ARTEMISIA

Tell the truth.

ORAZIO

Yes. I do.

TUTIA

Orazio! Those filthy diseases!

ORAZIO

What difference does it make! You never let me get near you. Bella, it's what men do. You're not supposed to take it seriously.

ARTEMISIA

Fine. I won't. I'll do it, too. As Tassi's wife, it will be my pleasure.

ORAZIO

You can't marry him!

ARTEMISIA

But Daddy, he's my fiancé. He's the man you chose for me.

ORAZIO

I didn't choose him! I caught him with his pants down!

ARTEMISIA

But Daddy, it was all your idea. My first lesson—

ORAZIO

What are you talking about?

ARTEMISIA

He raped me at my first class. You arranged it.

ORAZIO

This is outrageous!! He raped you in front of Tutia?!

ARTEMISIA

Tutia wasn't there.

TUTIA edges toward the door.

ORAZIO

What?! But she's supposed to stay with you.

ORAZIO and ARTEMISIA look at TUTIA.

TUTIA

Well—now—nobody said how long, Signore.

ORAZIO

YOU!

TUTIA

I was going to stay but then he accused me of being
suspicious of him and he was your best friend and you'd
get furious with me and my baby needed to be fed and
well, I couldn't do that in his presence and he seemed like
a nice man, being your friend and all—

ORAZIO

YOU!!!

TUTIA

(hysterical) You arranged the lessons with him. You should
have known better!

ORAZIO

I did! That's why I asked you to stay!!

TUTIA
Well—my baby—

ORAZIO
SHUT UP ABOUT THE FUCKING BABY!!!

TUTIA
Well, now Bella's engaged so the problem's solved.

ORAZIO
And whose idea was that!

TUTIA looks sheepish.

ORAZIO
(to TUTIA) YOURS?!

TUTIA
Well—no, not exactly—

ORAZIO
God! I'd like to wring your neck. This viper at my breast.
This is what happens when you try to be kind. I take in a
lodger and presto! the fangs go right into the heart.

TUTIA
You're charging enough for the apartment.

ORAZIO
You're making lots on the side. What did Tassi pay you?
Nice dress.

TUTIA
You'd never buy me one, you dirty old cheapskate!

ORAZIO
You bitch! You whore! Where's my painting!

TUTIA

What painting?

ORAZIO

Don't play innocent with me. My Judith. Who'd you let in last night?

TUTIA

I didn't let anyone in. If you go out and leave the gate unlatched, it's not my fault if people come in!

ORAZIO

People?! Who!!

TUTIA

Just Signore Cosimo. *(pause)* And a few friends.

ORAZIO

You let total strangers in to rob me?!

TUTIA

Cosimo's a friend of yours. Tassi sent him to pick up the dowry.

ORAZIO

AAAAAAGH!!!

TUTIA

Anyway, it wasn't any of my business—

ORAZIO

(flies into a rage and chases TUTIA) NONE OF YOUR BUSINESS!!! I'LL KILL YOU GODDAMMITT!!! THEN WE'LL SEE WHOSE BUSINESS IT IS!!! *(lunges at her)*

TUTIA shrieks and runs out.

ORAZIO

I'M SUING YOU! I'LL HAVE YOU PUT IN JAIL!! CHEAP
RENT THERE! *(laughs maniacally)* THAT BASTARD! HE
STOLE MY DAUGHTER AND NOW HE STEALS MY
PAINTING! WELL—HE'S NOT GETTING AWAY WITH
IT! DO YOU HEAR ME!! NONE OF IT! NOT ANY MORE!
I'M SUING HIM FOR THEFT AND FOR RAPE!

ARTEMISIA

You can't do that!

ORAZIO

Why? Are you afraid your fiancé won't stand up under
public scrutiny? DAMN RIGHT HE WON'T!!

ARTEMISIA

I'll deny the rape!

ORAZIO

Tassi will deny it, too and then you'll come out looking
like a whore.

ARTEMISIA

He wouldn't do that.

ORAZIO

Let's just put him to the test, shall we?

ARTEMISIA

No! Please!!

ORAZIO

Why not? Afraid you'll lose your fiancé.

ARTEMISIA

He'll return the painting. There's no need to press charges.

ORAZIO

No. Your honour's at stake and I'm going to defend it!

ARTEMISIA

But nobody knows it's lost.

ORAZIO

You think the people at that picnic aren't gossiping about
you. He degrades you to his level, then he doesn't have to
marry you.

ARTEMISIA

Please! Don't do this! You'll shame me!

ORAZIO

I'll make him pay for what he's done to you!

ARTEMISIA

But I love him!!

ORAZIO

(slaps her) Don't you ever say that again!

SCENE 5

INTERROGATOR, ARTEMISIA and ORAZIO.

INTERROGATOR
(exasperated) Did he rape your daughter or didn't he?!

ORAZIO & ARTEMISIA *(TOGETHER)*
(ORAZIO) Of course he did!
(ARTEMISIA) No! He didn't!!

INTERROGATOR
(to ORAZIO) There's no point proceeding if she denies the rape.

ORAZIO
(to ARTEMISIA) You can't do this to me. Tell him the truth.

ARTEMISIA
Signore Tassi and I are engaged to be married.

ORAZIO
Over my dead body!

ARTEMISIA
(glares at ORAZIO) If necessary!

INTERROGATOR
Excuse me, but did you and Signore Tassi engage in—erhem—sexual intercourse?

ARTEMISIA & ORAZIO *(TOGETHER)*
(ARTEMISIA) Yes!
(ORAZIO) She was raped!

INTERROGATOR
(to ARTEMISIA) How many times?

ORAZIO & ARTEMISIA *(TOGETHER)*
(ORAZIO) Many many times!
(ARTEMISIA) I can't say offhand. A lot.

INTERROGATOR
(confused) She was raped many many times?

ORAZIO
She screamed rape and Tutia and I caught him!

INTERROGATOR
Ah. *(to ARTEMISIA)* Did you scream rape?

ARTEMISIA
Yes—but I don't want to press charges.

ORAZIO
I'm the one pressing charges. She has nothing to do with it!

INTERROGATOR
Please, Signore Gentileschi, we could all save ourselves a lot of trouble. The charges of theft could still stand but as for the rape—since the defendant denies even knowing your daughter and your—

ARTEMISIA
Pardon?

ORAZIO
You heard him. Your fiancé says he doesn't know you.

ARTEMISIA
Is this true?

INTERROGATOR

When we arrested him, yes. We worked on him for a bit and he finally admitted that he'd heard of you. *(pause)* That you'd—erhem—acquired a certain notoriety. But that is neither here nor there, since you also deny the rape.

ARTEMISIA

Tassi raped me.

ORAZIO

Bella! *(hugs her)*

ARTEMISIA pushes ORAZIO away angrily.

INTERROGATOR

Now, are you sure about this? Because—

ARTEMISIA

Yes. I'm sure. I'll make my statement.

INTERROGATOR

Perhaps, in the interests of delicacy, your father should leave the room.

ORAZIO

(starts to leave) Yes.

ARTEMISIA

I want him to stay. I want him to know exactly what happened.

ORAZIO

(stops in his tracks) Oh.

INTERROGATOR

Well, let's begin then. *(to ORAZIO)* No interference, please. *(to ARTEMISIA)* When did he rape you?

ARTEMISIA

At my first art class. Just before Easter.

INTERROGATOR

How did he rape you?

ARTEMISIA

Well—you know. He held me down and he raped me.

INTERROGATOR

Did he hold you down with one hand? Or two hands? Did he pull your legs apart with his hands? Did he tie you up? Did he lie you down flat or did he press you up against a wall?

ORAZIO & ARTEMISIA *(TOGETHER)*

ORAZIO gasps.
(ARTEMISIA) Excuse me?

INTERROGATOR

We have to know every detail. We have to know what each part of his body was doing at each moment.

ARTEMISIA

Why?

INTERROGATOR

To see if you are telling the truth. To see if you were in fact, raped. If it was intercourse, his body parts would be in different places. You see, there is a technique to rape and we need to see if you describe it correctly.

ARTEMISIA

Oh. *(pause)* Well, it was my first class. He made several comments about my paintings. He pointed to one of the nudes and said it was my body. I denied it but he kept looking at it and then looking at me—

INTERROGATOR

No. The rape. Just tell us about the rape. Not the preamble.

ARTEMISIA

Oh. Well. He locked the door—then he grabbed me and threw me on the bed and—

INTERROGATOR

Where were his hands?

ARTEMISIA

One hand was holding my hands together. The other hand was holding my body down.

INTERROGATOR

So, you were flat on the bed.

ARTEMISIA

Yes.

INTERROGATOR

And he was on top of you.

ARTEMISIA

Yes. He pushed his knees between—

INTERROGATOR

One knee or two?

ARTEMISIA

One knee. Between my thighs so I couldn't close them. Then, he lifted up my skirts. *(pause)* With great difficulty. Then he let go of my hands and stuffed a paint rag in my mouth. I tried to push him away but by this time he had pushed my thighs apart with both knees and his penis was

about to enter me. He pushed and rammed it in. Is this what you want to hear?

ORAZIO listening in a state of agony.

INTERROGATOR

Yes.

ARTEMISIA

It burned against me and I screamed in pain but I had the rag in my mouth so no one could hear me. He withdrew his penis and as he was about to put it back in, I squeezed my thighs together so hard that I tore off a piece of his flesh.

ORAZIO sighs, as if to faint.

INTERROGATOR

(nods) Hmmm. Very good.

ARTEMISIA

He did not make anything of this and continued with his business. I started to bleed.

ORAZIO faints.

ARTEMISIA

That frightened him so he stopped.

ARTEMISIA and the INTERROGATOR slap ORAZIO's face to bring him to.

INTERROGATOR

A lot of blood?

ARTEMISIA

Yes.

INTERROGATOR

Hmmm. Well, thank you very much, Signorina
Gentileschi. We will be bringing in two midwives to
examine you.

ORAZIO

(revives) The bastard!

INTERROGATOR

Your daughter will be brought to court in five days time to
testify in front of the defendant. We're hoping that a
confrontation will reveal the truth.

ORAZIO walks out with the INTERROGATOR.

ORAZIO

(to INTERROGATOR) He's telling lies about her. My Bella.
She's very obedient. Very virtuous. Just a little high-
strung.

INTERROGATOR

I understand. I have a daughter, too.

*They leave. ARTEMISIA is left alone on stage. She
stares off into space.*

Light changes.

SCENE 6

HOLOFERNES and his slave, RATZO.

HOLOFERNES

I haven't seen that Hebrew woman about.

RATZO

She stays in her tent all day.

HOLOFERNES

There's no need for that.

RATZO

Count yourself lucky, master. You don't want that one in
your bed.

HOLOFERNES

I think I'll have a little get-together for the slaves.

RATZO

Oh no, master.

HOLOFERNES

A banquet. Tonight. Something small yet sumptuous.
Now, we can't leave the Hebrew woman out of the
festivities, can we? Go. Persuade her to join us. Don't tell
her it's for slaves. She might be offended.

RATZO

Please, master. This one is trouble. I can guarantee it.

HOLOFERNES

GO!

Scene 7

Ratzo, Judith and Tutia.

RATZO

Ah—Madame Judith.

JUDITH

Yes.

RATZO

Holofernes requests the pleasure of your company at a feast tonight. It is to be your initiation as one of the handmaidens of Ozymandias.

JUDITH

Oh.

RATZO

I wouldn't refuse if I were you.

JUDITH

Who am I to refuse my Lord. Whatever please Him, I will do it at once and it will be a joy to me until the day of my death.

RATZO

That's a yes? Fine. Eight o'clock. *(leaves)*

TUTIA

Oh Madame Judith, we'll be ruined. I knew staying in the tent would do no good. We should never—

JUDITH

Tutia. Prepare my food. Pack it in the basket with the cloth. Don't forget my wine.

TUTIA

That's not wine.

JUDITH

They don't know that.

TUTIA

Do you have a plan?

JUDITH

I hope so. Wait outside the tent if you can. We'll be going out for our usual stroll.

TUTIA

Do you think Holofernes will let you?

JUDITH

If all goes well, he might even be joining us.

Scene 8

The Banquet.

Holofernes' tent. Holofernes (Tassi),
Cosimo, Giambattista, Lisa, Ratzo (Orazio),
Judith and Old Man.

HOLOFERNES
Isn't she beautiful! Isn't she the most exquisite creature on
the face of the earth!

COSIMO
Why don't you fuck her and get it over with.

HOLOFERNES
What a terrible thing to say. *(to Judith)* Don't listen to
him, my darling. These Assyrian men are very crude. Are
Hebrew men as crude as well?

JUDITH
Some.

GIAMBATTISTA
Are Hebrew men as beautiful as their women?

LISA
I don't think she's so beautiful. She's very large.

HOLOFERNES
That's because you are very small. With the brain of a
gnat. You are a slave but Judith will be my queen.

LISA
(to Judith) He's said that before. *(imitates)* "You will be
my queen."

HOLOFERNES

I never said such a thing! Don't even think to compare
yourself! Judith is a princess. She is good, kind and wise.
(to JUDITH) You're an angel.

JUDITH looks away.

HOLOFERNES

Yes. You are. You are my guardian angel and I adore you.
(takes her hand and kisses it) Will you protect me tonight?
(to group) I embarrass her. See how she blushes.

OLD MAN

I wouldn't mind a Hebrew woman myself. *(to JUDITH)* Do
you have any sisters?

HOLOFERNES

Enough! You should be satisfied with the woman you
have. *(indicates LISA)*

OLD MAN

She didn't satisfy you. Why do I have to put up with her.

LISA

Because you're old and you're ugly. That's why.

OLD MAN

(to HOLOFERNES) Did she talk like that to you?

COSIMO & HOLOFERNES *(TOGETHER)*

(COSIMO) Always.
(HOLOFERNES) Never!

GIAMBATTISTA

(to JUDITH) Holofernes is truly smitten with you. I've never
seen him like this before. Don't hurt him.

JUDITH

Hurt him?

GIAMBATTISTA

Break his heart.

JUDITH

His heart will remain in one piece.

COSIMO

(to JUDITH) Have some more wine. We're all getting smashed here and you've hardly touched yours. *(starts to pour wine into JUDITH's glass)*

JUDITH

I brought my own wine. *(takes glass away)*

COSIMO

Holofernes isn't stingy. Have some of ours.

JUDITH

NO! I mean—I have to drink my own wine.

COSIMO

It's an odd colour for wine. *(sniffs it)* Smells like— *(takes JUDITH's glass)*

JUDITH

You musn't drink it!

COSIMO

(takes a sip) This isn't wine. It's grape juice.

HOLOFERNES

What?

JUDITH

It's Hebrew wine, my lord. It's very sweet.

COSIMO

It's not fair that we should get absolutely pissed and she
should sit there watching.

JUDITH

Hebrew wine is just as potent. But I admit, I haven't drunk
much. *(raises her glass)* I will drink now, my lord, because
my life means more to me today than in all the days since I
was born.

LISA

That's overdoing it a bit, isn't it.

GIAMBATTISTA

You haven't said you loved our master.

HOLOFERNES

She speaks in poetry.

GIAMBATTISTA

Or riddles.

LISA

It's not riddles. I like riddles.

HOLOFERNES

(raises glass) To Judith! Drink up my darling. We've a long
night ahead of us.

SCENE 9

HOLOFERNES' tent.

*HOLOFERNES, JUDITH and RATZO. RATZO is
standing by the door. JUDITH and HOLOFERNES
are lying on a mattress underneath a purple
canopy.*

HOLOFERNES
(very drunk) This Ozymandias stuff. It's all bullshit, you
know. *(to RATZO)* Don't listen to me Ratzo. Your master's
drunk. He doesn't know what he's saying. *(to JUDITH)* I
know exactly what I'm saying. Why should anyone
worship a man. It's stupid. I wish I could believe in a god
the way you do.

JUDITH
You make it sound as though it's strictly arbitrary.

HOLOFERNES
It is. Why else are there so many people believing in so
many gods.

JUDITH
There's just one. Jehovah.

HOLOFERNES
And Ishtar, Isis, Nuit, Ninmah, Kubala. Now I think there
probably is just one. But why kill each other over a name.
God! I'm so bored with war. It's not who I really am. It's
just a life I fell into. I'm good at it.

JUDITH
I'm sure you are, my lord.

HOLOFERNES

Oh no—not this "my lord" stuff. Please—not tonight. I want it to be just you and me. Alone. *(pause)* Ratzo, you're dismissed.

RATZO

But master, I could serve the wine.

HOLOFERNES

Ratzo!

RATZO

As you wish. *(leaves)*

HOLOFERNES

Do you love me, Judith?

Lights down.

Scene 10

Artemisia, staring off into space. Giambattista sneaks up behind her.

GIAMBATTISTA

Artemisia?

Artemisia gasps, freezes.

Giambattista comes up behind her—grabs her, claps hand over her mouth.

GIAMBATTISTA

Don't scream. Promise me you won't scream. It's very important. Agostino has to talk to you. He asked me to take you to him. *(releases hand cautiously)*

ARTEMISIA

I'm not visiting him in prison!

GIAMBATTISTA

They let him out for a walk around the grounds. Come to the gate with me. He has to talk to you. It's urgent.

ARTEMISIA

He said he didn't even know me!

GIAMBATTISTA

He wouldn't do it if he didn't have some better plan in mind. I know him.

ARTEMISIA

Maybe you're as deluded as I am about him.

GIAMBATTISTA

(holds out hand) Come!

Scene 11

Evening. Grounds outside the prison.

Artemisia and Giambattista enter and walk around nervously.

Tassi

Pssst. Darling, over here.

Artemisia walks over to Tassi, reluctantly.

Tassi

Why are you accusing me of such things? I thought we had an understanding.

Artemisia

I told the truth. You said you didn't even know me!

Tassi

(horrified) Is that what they told you?

Artemisia

Yes. You mean, you—

Tassi

Of course not. You see, they didn't arrest me because of you. They arrested me because of my wife.

Artemisia

You're still married?!

Tassi

No. She's dead. Now, she was a horrible person and I'm not sorry. But that's the problem, see. Because she was so horrible, they think I killed her.

ARTEMISIA

How did she die?

TASSI

A band of thieves broke into her house. They robbed her
and then they murdered her. I was in Naples at the time.
But people think I hired these men.

ARTEMISIA

Lisa is your wife's sister, isn't she?

TASSI

Yeah, what about it?

ARTEMISIA

You had an affair with her.

TASSI

I swear I didn't kill my wife! You must believe me!

ARTEMISIA

Do you think Lisa hired them?

TASSI

God! I never thought of that. It's possible. The problem
is—the longer I'm in jail, the more time they'll have to
manufacture evidence against me. If I admit to raping you,
they'll put me away for five years—

ARTEMISIA

Five years?!

TASSI

Yes. Didn't your father tell you that?

ARTEMISIA

I couldn't stop him from pressing charges!

TASSI

You could have denied the rape. But it's all right. Don't blame yourself. I think we can still salvage the situation. You'll have to say that someone else raped you.

ARTEMISIA

I can't do that. I've already told them what happened.

TASSI

Say you made a mistake. It was Cosimo instead. It all happened in the dark and you mistook Cosimo for me.

ARTEMISIA

But it happened in broad daylight. I can't take back what I said.

TASSI

You're worried about what people might say.

ARTEMISIA

People are already talking. I've been publicly declared a whore. By your friends.

TASSI

That was Cosimo. You can get your revenge on him by—

ARTEMISIA

No! I won't do it.

TASSI

A small leap of faith. All I ask of you is this small leap of faith and you can't do it. You don't trust me.

ARTEMISIA

I trust you.

TASSI

Then why are you taking your father's side against me!

ARTEMISIA

I have to tell the truth.

TASSI

Why? To please your father? He's put you up to public ridicule! He only pressed charges because of the bloody painting! He couldn't care less about you. It's his money he's worried about.

ARTEMISIA

No! That's not true!

TASSI

Why is he prosecuting me, now? DAMN IT! He hired me to rape you. IT WAS A JOB!

ARTEMISIA

(faltering) You don't love me.

TASSI

What would be the point! You're in love with your father! Go ahead. Testify against me. You and your father deserve each other! *(leaves)*

ARTEMISIA

Please, Agostino!

TASSI

(shouts in the dark) LET NO MAN PUT ASUNDER!

SCENE 12

THE TRIAL

TASSI on one side. ARTEMISIA on the other. The INTERROGATOR presides. (He should be played by the same actor who played the OLD MAN.) ORAZIO, TUTIA, COSIMO, GIAMBATTISTA and LISA present.

INTERROGATOR

Do you, Artemisia Gentileschi, hereby swear that your statement of March 11th is true?

ARTEMISIA

I do.

INTERROGATOR

Do you maintain that the defendant, Agostino Tassi, raped and deflowered you?

ARTEMISIA

I do.

TASSI

Many many times.

COSIMO and LISA titter.

INTERROGATOR

Please—no interruptions from the defendant.

TASSI

But your Honour, I am simply repeating the charges as they stand. According to Signore Gentileschi, I raped his

daughter many many times. As, I am sure, did a number of men before me.

More titters.

INTERROGATOR
Silence. Signorina Gentileschi, is there anything you wish to change in your testimony?

ARTEMISIA
No.

INTERROGATOR
You swear you are telling the truth.

ARTEMISIA
Yes. Tutia will vouch for me.

INTERROGATOR
Signora Liotta says she doesn't know whether you were raped or not.

ARTEMISIA
What?! Tutia!

TUTIA
(scratches herself) I wasn't there.

ARTEMISIA
But you know what happened. My clothes!

TUTIA
You could have torn them yourself.

ARTEMISIA is astonished.

TUTIA

You spend a couple of weeks in jail and see how you feel.
Your father should have thought twice—

ARTEMISIA

Tutia—please!

TUTIA

And don't say he didn't mean to do it! That old bugger
gets away with blue murder and he always says he didn't
mean it. *(scratches furiously—picks something off herself)*
Damn! I knew it! Lice!

> *She throws it away. People in the vicinity
> scurry away.*

INTERROGATOR

We don't like to do this but it appears to be necessary.

> *He pulls out the torture instrument—"Les
> sybilles"—thumbscrews that go around the
> fingers.*

ORAZIO

You're going to torture my daughter?! Why don't you
torture that bastard! *(points to TASSI)*

INTERROGATOR

(while adjusting instrument) We've tried it. Torture is
completely ineffectual on a man of his character. The
defendant has aggressively maintained that he didn't
know your daughter. However, we had a brief
conversation with his friend, Giambattista Stiatessi and he
confirmed that they were acquainted.

TASSI

(to GIAMBATTISTA) WHAT!

GIAMBATTISTA shrugs.

INTERROGATOR
Anyway, Signore Gentileschi, these are mild instruments.
They merely serve to get the truth out of her. *(to
ARTEMISIA)* Now, do you swear you are telling the truth?
You were a virgin before you met Signore Tassi? *(adjusts
screws)*

ARTEMISIA
Aaaagh! YES!

INTERROGATOR
YOU WERE A VIRGIN?

ARTEMISIA
YES!!

INTERROGATOR
(to ORAZIO) I apologize for the repetitive nature of my
questioning and please excuse me if I sound abrupt.
(shouts) WERE YOU A VIRGIN!

ARTEMISIA
AAAAAAGH! YES YES I WAS A VIRGIN!!!

INTERROGATOR
AND DID AGOSTINO TASSI DEFLOWER YOU?

ARTEMISIA
Yes! Yes. He did.

INTERROGATOR
HE DID WHAT?

> The INTERROGATOR *tightens the screws
> periodically.*

ARTEMISIA

AAAAGH! HE RAPED AND DEFLOWERED ME!!

INTERROGATOR

Did Agostino rape you?

ARTEMISIA

YES!!

INTERROGATOR

Did any other man rape you?

ARTEMISIA

AAGH! NO!

INTERROGATOR

And everything you've said is true.

ARTEMISIA

IT'S TRUE! IT'S TRUE! IT'S TRUE! *(leans over to TASSI—holds up thumbscrews)* THIS IS MY ENGAGEMENT RING AND THESE ARE YOUR PROMISES!!!

INTERROGATOR

Yes, well, thank you, I think that's sufficient. *(He undoes the thumbscrews.)* Perhaps we should torture Signore Tassi as well. For old times's sake, the rack.

TASSI

All right. I'll tell you exactly what happened. In full detail. *(pause)* It's true. I knew Artemisia Gentileschi. How could you not know her. She was notorious. Orazio was away a lot so she used to turn tricks in the studio.

ORAZIO & TUTIA *(TOGETHER)*

(ORAZIO) What!
(TUTIA) Oh my God!

ARTEMISIA

It's not true!

TASSI

Fitted it out for each client. The Judith set was the patron's favourite.

TUTIA

So, that's why you always wanted to play Judith!

ARTEMISIA

TUTIA! He's lying. Agostino!

TASSI

Though some people preferred her Salomé. But that's another story. At that time, I hadn't met her. I was good friends with her father, Orazio.

ORAZIO

VIPER!

TASSI

He begged me to give her art classes. Mainly to give her something else to do with her time. I don't blame her for whoring. Everyone knows Ratzo is a dirty old skinflint who wouldn't give a dying man a dime.

TUTIA

Yeah! You old piker!

ORAZIO

LET ME AT HIM! I'LL GIVE HIM HIS DIME!!

ORAZIO is restrained by COSIMO and GIAMBATTISTA.

TASSI

Artemisia told me that she started selling herself when her father went to Padua on a three-month commission and left her without any food or money.

ORAZIO

LIES!!

ARTEMISIA

STOP HIM! HE CAN'T SAY THESE THINGS!!

INTERROGATOR

(pounds gavel) SILENCE! ALLOW THE DEFENDANT TO CONTINUE!

TASSI

I arrived for the class. I was surprised that we were alone. Apparently, Orazio had left Tutia to chaperone but Signorina Gentileschi had sent her away.

ARTEMISIA

Why are you lying? Please, Agostino!

TUTIA

Is he talking about the first or second lesson?

TASSI

Your Honour, I find it hard to concentrate with all these interruptions. Could we please restrain the plaintiff?

INTERROGATOR

(to ARTEMISIA) Silence or we will gag you.

TASSI

Signorina Gentileschi was dressed provocatively but I pretended not to notice.

ARTEMISIA

(stands up) But everything he says is a lie!

INTERROGATOR gags ARTEMISIA.

TASSI

Perhaps something to hold her to the chair.

*COSIMO dashes up, with a long scarf. He ties
ARTEMISIA to the chair. The INTERROGATOR looks
at him doubtfully.*

TASSI

I asked her to bring out her pencils. She said she kept
them in a very special place and I could draw one out, if I
wished. She then drew up her skirt to reveal a range of
pencils, held in place by a garter— *(coughs)* —hem!
strapped to her thigh. I reached out to take one and she
laughed and pulled her skirt down. I thought that was the
end of the matter and moved away. She then grabbed my
hand and said, "I'll guide you. You'll want one that has a
soft point." Well—she—ah—took my hand and—need I
continue?

*The INTERROGATOR and the entire court are
leaning forward with avid interest. ORAZIO is
open-mouthed. ARTEMISIA makes protesting
noises.*

INTERROGATOR

Please. I mean—yes, do continue.

TASSI

She drew my hand up her skirt and proceeded to amuse
herself.

143

ORAZIO
THESE ARE LIES!! BASE SLANDER!!

*ARTEMISIA makes noises through the
handkerchief.*

INTERROGATOR
(to ORAZIO) SILENCE or you leave the court! *(to TASSI)*
Continue.

TASSI
I quickly withdrew my hand. I said her behavior was
disgusting and that I would tell her father. She replied,
"Oh, that stingy old fart. If I'm going to put out, then I
better get paid. And if he won't pay me, I'll find someone
who will."

INTERROGATOR
What did she mean by "put out"?

TASSI
I believe she was referring to certain services rendered.

INTERROGATOR
Such as?

TASSI
She posed for his paintings. Nudes. Admittedly, not many.
Orazio was afraid of gossip. I inferred from the remark
that they had an incestuous relationship.

ORAZIO, ARTEMISIA & TUTIA, AT ONCE:

ORAZIO gasps, clutches heart, faints.

*ARTEMISIA struggles, kicks chair, makes as much
noise as possible.*

144

TUTIA

Oh my God!

GIAMBATTISTA goes to ORAZIO.

GIAMBATTISTA

Sir, are you all right? *(tries to revive him)*

TUTIA

He's not dead, is he? *(slaps ORAZIO's face)*

TASSI

See! This is what comes of telling the truth!

ORAZIO

(revives, sees TUTIA) Get away from me, you stupid old cow!

COSIMO

(stands up) TASSI'S WRONG.

ORAZIO

Finally!

COSIMO

Artemisia and Ratzo did not commit incest. Because *(pause)* I am Artemisia's father. Many years ago, Ratzo's wife, Prudentia—

ORAZIO

God! *(faints again)*

TUTIA

(gasps) Oh no! Really?!

COSIMO

But it's true. We look alike and everything. She's a right slutbag. Gets that from me. When she started her brothel—I was her first customer!

INTERROGATOR

Will someone please remove this revolting person from the room.

GIAMBATTISTA takes COSIMO out.

COSIMO

But it's true! Tassi didn't rape her! I did! That's how great families are made. Gotta keep the blood pure!

Door slams behind COSIMO. GIAMBATTISTA returns. Tassi has his head in his hands. ORAZIO starts to come to.

INTERROGATOR

(to TASSI) Is that man a close friend of yours?

TASSI

An acquaintance.

INTERROGATOR

(to ARTEMISIA) Have you anything to say to all this?

ARTEMISIA stares at him.

INTERROGATOR

Oh sorry. *(removes gag)*

ARTEMISIA

And the scarf, please.

INTERROGATOR unties her.

ARTEMISIA tries to rush at TASSI. The
INTERROGATOR, with some difficulty, keeps her
in the witness box.

GIAMBATTISTA

(stands up) She's innocent!

TASSI

(lurches in chair) What the—

GIAMBATTISTA

Look, I love Agostino very much but I can't stand by and
watch him destroy this girl's life. Agostino is lying. He
and Artemisia must have had a fight. Agostino is very
vindictive when he's angry, but I know he doesn't mean
what he's said.

TASSI

Bullshit!

GIAMBATTISTA

He loves Artemisia. He told me so himself. You can
imagine how this hurt me. I thought our love was—

INTERROGATOR

So, Artemisia didn't run a brothel?

GIAMBATTISTA

No.

TASSI

Don't believe him! He's only saying this to get back at me!

INTERROGATOR

Did Agostino rape her?

GIAMBATTISTA
He told me he did. But he did it out of love.

ARTEMISIA & TASSI
BULLSHIT!

GIAMBATTISTA
All I know is this. Agostino loves Artemisia and wants to
marry her but he had a lot of problems so he couldn't.

LISA
Are you calling me a problem!

GIAMBATTISTA
The whole case should be dropped. Agostino should give
back the painting and the two of them should get married.

ARTEMISIA & TASSI *(TOGETHER)*
(ARTEMISIA) I'll never marry that snivelling liar!
(TASSI) I'll never marry that conniving whore!

LISA
He can't marry anyone. He's married to me!

ARTEMISIA
WHAT?!

INTERROGATOR
Aren't you supposed to be dead?

LISA
Do I look dead to you, Buster!

INTERROGATOR
Which wife are you?

LISA

How many does he have!

ARTEMISIA

Trust me?! Ha!! *(jumps up over enclosure, runs over to TASSI)*

TASSI

(backs away) No! She's lying! She's not my wife! OW!

ARTEMISIA attacks TASSI, kicks him and bites him.

ORAZIO

(to LISA) But your husband?

LISA

He died last week. And if you think I'm going to buy your lousy painting, forget it!

ORAZIO

But the money! Who's going to pay—

LISA & TUTIA *(TOGETHER)*

(LISA) Not me, that's for sure! I don't want your ugly daughter on my wall.
(TUTIA, *to ORAZIO*) Serves you right! You miserable old fart! *(kicks him)*

ORAZIO

Who are you calling ugly!

LISA

Your daughter, Dumb Ass!

ORAZIO rushes to attack LISA.

TASSI

(still struggling with ARTEMISIA) HOLY CHRIST! GET HER
OFF ME!!

LISA

(tries to haul ARTEMISIA off) Get your filthy paws off my
husband!!

ARTEMISIA

Your husband?!! *(fights with LISA, pulls at her hair)*

ORAZIO

(attacks TASSI) YOU BASTARD!!! SELL THE PAINTING
TWICE OVER!! ONCE TO A DEAD MAN!! AND THEN
TO SOMEONE ELSE!!

TASSI

HELP!!! GIAMBATTISTA HELP!!

> *GIAMBATTISTA goes to help TASSI.*

> *TASSI punches GIAMBATTISTA in the nose.*

TASSI

WHAT'D YOU OPEN YOUR BIG MOUTH FOR!! YOU
TRAITOR!! COSIMO!! GET IN HERE!!

> *COSIMO rushes back in. He attacks
> GIAMBATTISTA. Bedlam ensues. Chairs are
> thrown.*

INTERROGATOR

(shouting above chaos) LOCK THEM UP!! LOCK THEM
ALL UP!!

Scene 13

The Studio.

There is a gilt frame around the HOLOFERNES set, as though a painting is resting against it. A piece of drapery falls from top to bottom, acting as a canopy. ARTEMISIA carries a long sword. She is practising sword moves. She hears people coming. She hides. TASSI and ORAZIO stagger in. They are hauling in ORAZIO's "Judith."

TASSI
(plunks it down) There! Your fucking painting's back. Sign here, please. *(pulls out paper, hands it to ORAZIO)*

ORAZIO
What?

TASSI
Proof that I returned it.

ORAZIO signs.

TASSI
Thank you. *(starts to leave)*

ORAZIO
Tassi.

TASSI
What?

ORAZIO
I'm worried about Bella.

TASSI

Oh, fuck off, Ratzo. Just Fuck Right Off!

ORAZIO

I can't talk to anyone else about this.

TASSI

That's because we all hate you. *(starts to leave)*

ORAZIO

Bella's gone mad.

TASSI stops.

ORAZIO

She took all her paintings and she locked them in her room. And now, she lurks.

TASSI

She lurks.

ORAZIO

Well—yeah. I haven't seen her but I can feel her. Lurking.

TASSI

I did not drive your daughter mad.

ORAZIO

You publicly humiliated her.

TASSI

You made it public, Ratzo. I was simply defending myself. If I'd confessed, I would have been locked up for five years—which I guess, is precisely what you wanted. It was okay for me to rape your daughter, but not okay to marry her.

ORAZIO

You're low-life, Tassi.

TASSI

No lower than you.

ORAZIO

Maybe not, but I, at least, have aspirations. Giambattista's
cousin, Tony has agreed to marry Bella.

TASSI

How very boring for her.

ORAZIO gives him a dirty look.

TASSI

But very respectable. She'll get a lot of work done. Won't
be much amusement at home. She'll have to paint.
Anyway, count your blessings. Your daughter's going to
be an artist, after all. And you don't have me as a son-in-
law.

ORAZIO

Let's drink to it. *(rummages around for a bottle of wine which
is on the HOLOFERNES set)* Here's to Art!

TASSI

Here's to not being a son-in-law!

They drink.

ORAZIO

Do you think I'm despicable.

TASSI

We're two of a kind, Ratzo.

ORAZIO

I was simply trying to do what's best for her. I didn't want her to waste her talent. You would have destroyed her.

TASSI

Maybe.

ORAZIO

She hates me, now.

TASSI

That's not surprising.

ORAZIO

She hasn't spoken to me since the trial. But when she's my age she'll know why I did it. *(pause, takes a swig)* I'm willing to wait.

They drink.

ORAZIO

She was so innocent. It's awful when they lose their innocence.

TASSI

Yeah.

ORAZIO

(stands up) To Bella! She will be the greatest painter in all Rome. She will surpass Caravaggio!

TASSI

Caravaggio's dead, Ratzo.

ORAZIO

What?

TASSI

He died over a year ago in a knife fight.

ORAZIO

WHAT?!

TASSI

Nobody liked to tell you, Ratzo. It was your mission in life to hate him. So, we all kept the bad news from you.

ORAZIO

Who killed him?

TASSI

Oh well—now, that's another awkward—ah—

ORAZIO

You killed him, didn't you!

TASSI

Well—yeah—I got mad. He was cheating at cards again and I hate it when—

ORAZIO

YOU KILLED CARAVAGGIO?! THE MAN WAS A GENIUS AND YOU KILLED HIM!!

TASSI

You never liked him, Ratzo. Anyway, you have Bella.

ORAZIO

YOU WOULD HAVE KILLED HER, TOO!! YOU'RE A MONSTER!!

> *ORAZIO punches TASSI in the face and knocks him out. He takes a long swig of wine and passes out, collapsing in a heap.*

ARTEMISIA comes out from her hiding place. She is carrying a sword. She walks over to TASSI and prods him with the sword.

TASSI groans, comes to, sees ARTEMISIA and tries to get up.

ARTEMISIA
(stops him with the sword) I thought so. A coward.

TASSI
Artemisia—please!

ARTEMISIA
Flirt with danger but only if you have all the weapons. I'm on the edge now, Agostino. THE CUTTING EDGE!!

She raises the sword.

Blackout.

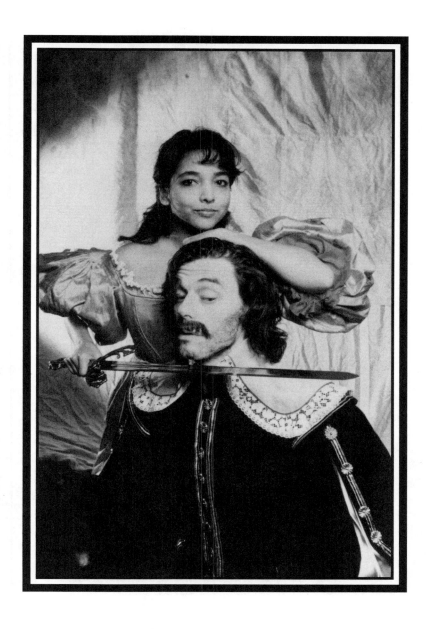

Pamela Sinha as ARTEMISIA *and Tom McCamus as* TASSI. *Photo by David Lee.*

Pamela Sinha as Artemisia. *Photo by David Lee.*

SCENE 14

*JUDITH and her maid, TUTIA. JUDITH is carrying
the basket. HOLOFERNES' head is wrapped in the
red and white checked cloth in the basket.*

JUDITH and TUTIA move furtively.

HEAD

Judith.

JUDITH stops, freezes in her tracks.

TUTIA
(goes on ahead, stops) What's the matter, Ma'am?

JUDITH
Did you hear something, Tutia?

TUTIA
No. Come on. The town gates are up ahead.

They walk again.

HEAD

Judith.

JUDITH
Tutia, give me a few moments alone.

TUTIA
You have to talk to Jehovah?

JUDITH
Just leave me alone.

159

TUTIA withdraws. JUDITH looks in the basket.
She lifts the cloth off the head.

HEAD
Judith.

JUDITH drops the cloth back over the head.

HEAD
I love you, Judith.

JUDITH lifts the cloth up again. She gazes in
morbid fascination.

HEAD
I love you, Judith. Keep me with you. Put my head on
your pillow. I'd love to see you in the morning. Eyes
blurred with sleep. That sweet fresh dead look that people
have. Those few precious moments of the soul.

JUDITH
(gasps, covers head) Tutia!

TUTIA
Ma'am?

JUDITH runs past TUTIA, stands in front of the
town gate.

JUDITH
OPEN THE GATE! OPEN THE GATE!! *(pulls head by the*
hair out of her basket) THE HEAD OF HOLOFERNES!
PRAISE GOD! PRAISE HIM! Praise Jehovah who has
conquered our enemies by my hand tonight. HANG THIS
HEAD UP FOR ALL TO SEE! LET HOLOFERNES MEN
SEARCH AND FIND HIM HERE!!!

TUTIA runs up and joins JUDITH.

TUTIA
Calm down, Ma'am. It's going to be all right.

JUDITH
(fevered) THE HEAD OF HOLOFERNES!!! SLAIN BY MY
HAND!! THE HAND OF A MERE WOMAN—

One of the guards comes down from the gate.

*TUTIA takes head from JUDITH and hands it to
him.*

TUTIA
That's very good, Ma'am. Now, let's go to your tent.
You've had a busy time.

JUDITH
THE HEAD OF HOLOFERNES—

TUTIA leads JUDITH off.

SCENE 15

The Studio.

*ARTEMISIA stands over TASSI, sword raised to
strike. She looks at TASSI and allows him to
escape. She walks over to ORAZIO. She is still
carrying the sword. She kicks ORAZIO.*

ORAZIO grunts.

ARTEMISIA boots him again.

ORAZIO

OW! Bella?

ARTEMISIA

Judith, Daddy. My name is Judith, now. You've got your
wish. Your Judith has come back to you. *(raises sword)*

ORAZIO

AAaah! *(clambers out of the way)*

ARTEMISIA

(stalks him) What's the matter, Daddy? Don't you want
your Judith anymore?

ORAZIO

Where's Tassi?

ARTEMISIA

(laughs) Oh—I've taken care of him.

*She walks over to ORAZIO's painting and points
to it with the sword.*

ARTEMISIA

This is your moment. Frozen in time. This is who I am in your eyes? Was I ever really like that? That agreeable? That content? *(walks over to the JUDITH set)* Now THIS is a painting. "My Little Daughter Bella About To Chop A Head Off."

> *She pulls the canopy off the gilt frame to reveal her painting, "Judith Beheading Holofernes." [The painting can be presented by using a copy or a slide.]*

ARTEMISIA

Why don't you paint one like that, Daddy.

ORAZIO

My God! Is that your new painting?

ARTEMISIA

Yes. *(laughs)* I have taken my revenge on Agostino Tassi. He is dying as we speak. An ignominious and gruesome death. Dying for all eternity and all the world shall be witness.

ORAZIO

What?

ARTEMISIA

(crying) You've done what you set out to do, Daddy. I'm not your little girl, anymore. I'm something else. Something truly unspeakable. An artist! GOD DAMN YOU!! *(throws sword down and leaves)*

ORAZIO

Bella! Come here this instant! *(pause)* Bella? Bella, I order you to come back! *(pause)* Bella!

He breaks down sobbing, looks up at frame.

SCENE 16

ORAZIO backs away in awe. A group of people gather and stare at the painting. LISA and GIAMBATTISTA are off to one side.

LISA

And did you see what she did.

GIAMBATTISTA

Heard about it. Haven't been able to see it.

LISA

It's on public exhibit.

GIAMBATTISTA

It's packed with people. I'll have to wait till the furor dies down. What's it look like?

LISA

Well—she's got him lying there with his throat slit, bleeding like a pig and she's painted herself hacking away at him.

GIAMBATTISTA

How does he look?

LISA

Very surprised.

GIAMBATTISTA

No. No, nude! How does he look nude?

LISA

You've seen him nude.

GIAMBATTISTA

We've all seen him nude. But how did she paint him? Did she make him look sexy?

LISA

She made him look like a side of beef.

GIAMBATTISTA

Great! He'll never live it down.

LISA

(whispers) Talk of the town.

GIAMBATTISTA

(whispers) Talk of the town.

CROWD

(whispers) Talk of the town.

Scene 17

Artemisia and her husband, Tony, are in bed. They are lit only by the slide projection of the painting, "Judith Beheading Holofernes" above the headboard of the bed.

TONY

I'm not having that painting hanging over my head! In fact, as your husband, I forbid you—

ARTEMISIA

And as my lover?

TONY

Pardon?

ARTEMISIA

As my lover, how would you feel about it, then?

TONY

It puts me off. I can't concentrate.

ARTEMISIA

What's the matter, Tony? Don't I moan enough for you?

TONY

You don't love me!

ARTEMISIA

I'm trying to love you.

TONY

Damn it! It's not the same thing.

ARTEMISIA

It's the best I can do.

TONY

What's wrong with me?

ARTEMISIA

There's nothing wrong with you, Tony. You're a sweet loving husband.

TONY

And you don't want that, do you. You want someone like Tassi.

ARTEMISIA

Agostino is dead for me.

TONY

You'll never be free of him. What do you want me to do? Who do you want me to be? *(flings himself down on her and tries to claim his conjugal rights)* What do I have to do to make you love me!

> ARTEMISIA *lies back, her head upside down, facing the audience in the "Holofernes" position.*

TONY

Make you love me! MAKE YOU LOVE ME! MAKE YOU LOVE ME!!

THE END